D0489798

HUGH BAIRD COLLEGE 759.
BALLIOL ROAD 3
BOOTLE L20 7EW WR1
TEL: 0151 353 4454
T65168

Return on or before the last date stamped below.

21.4.11

CLASS

759.3 WRI

ACQ T

15/4/11 ✓ T65168

4

First published 2010 by

National Museums Liverpool

127 Dale Street

Liverpool

L2 2JH

All images © 2010 David Lewis and family interests

Introductory text and catalogue entries © 2010 Christopher Wright

The authors' rights have been asserted by them in accordance with the
Copyright, Design and Patents Act 1988.

All rights reserved. No part of this book may be reproduced, stored in a retrieval system,
or transmitted, in any form or by any means, electronic, mechanical or otherwise, without
the prior written permission of the publisher.

A British Library CIP record is available.

ISBN 978-1-902700-44-1

Designed by Pointing Design

Printed and bound by Everbest

A Collector's Eye

Cranach to Pissarro

HUGH BAIRD COLLEGE
LIBRARY AND LEARNING CENTRES

Walker
Art Gallery

National Museums Liverpool

Contents

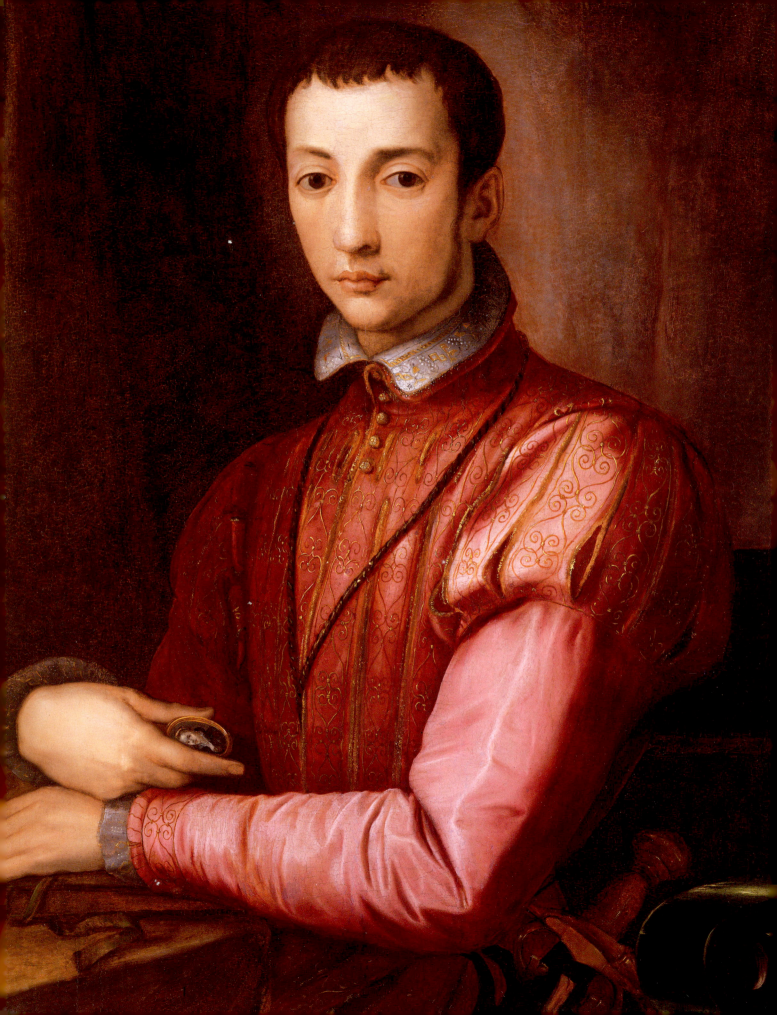

A Collector's Eye

The creation of a private collection is an intensely personal exercise. The objects so gathered would exist whether or not brought together in one ownership. Such a collection may reflect the vanity of the collector, or it may, hopefully, reflect an intellectual curiosity which can to some extent be satiated by the juxtaposition of period, style, subject, medium, artist or creator. This fulfils a subjective desire to learn and appreciate in the comfort and accessibility of one's own possessions, rather than within the public domain.

Nevertheless, the private rather than public satisfaction of intellectual curiosity contains an inevitable element of vanity. Artistic endeavour whether from a composer, writer, poet, architect, sculptor or artist belongs in the public domain. Ownership is ephemeral, but the act of private ownership is itself an endeavour which can provide an insight into the very process of selection and acquisition.

Such personal choice is almost certainly influenced by the taste, culture and fashion of the time. Intellectual curiosity seeks to overcome such influences, to reflect the richness of the past notwithstanding contemporary pressures.

Inevitably any collection created over a period of years, whether private or public, is opportunistic. The object needs to be available, not merely desired. Sufficient funds have to be available to render the object affordable whether from private or public resources.

Once identified there are three principal responses to artistic creation, namely intellectual, emotional and aesthetic. One may find a piece of music difficult to the ear, but fascinating in its place in musical history or development, and of inexplicable emotional impact. Or it may be delightful to the ear, but of little emotional impact or historical interest. So with a painting one may revel in its perceived

beauty, but have no emotional response or find no place for it in art history. Equally, the image may not appeal but it may have powerful impact and represent a time of historical significance.

As our family interests brought together several hundred paintings over a period of thirty five years or more, a policy evolved where at least two out of these three responses should be positive. Where all three are present, the pleasure and satisfaction is intensified.

For example, the Reymerswaele St. Jerome. This image, repeated frequently by the artist, would not necessarily have great aesthetic appeal. The Saint has the typical claw-like hands Reymerswaele depicts. His visage is grim. The subject is spartan. Yet the artist himself is a fascinating figure, who repeated many versions of a small number of subjects, and whose status is exemplified by the great number of replicas of his images after his lifetime. The subject itself has huge impact; St. Jerome translating the Bible, living in isolation in the desert, a fundamental contrast with much of contemporary existence. Such contrasts are the very essence of a collection.

The distinction between a public collection and a private collection is clear. The public need and deserve an opportunity to see and experience objects of art from all ages, collected objectively, to educate, to inform, and create the basis for public enjoyment and enlightenment irrespective of economic considerations. A private collection is subjective and may or may not have motives wholly related to intellectual rigour. It is however possible to combine the two by creating private collections, and sharing them with the public.

A high proportion of our collections over the years has been loaned to institutions, normally on a long term basis. We have sought to satisfy our own intellectual curiosity, but also to have the satisfaction of assisting many public bodies to fill gaps, or complement existing holdings, for public benefit.

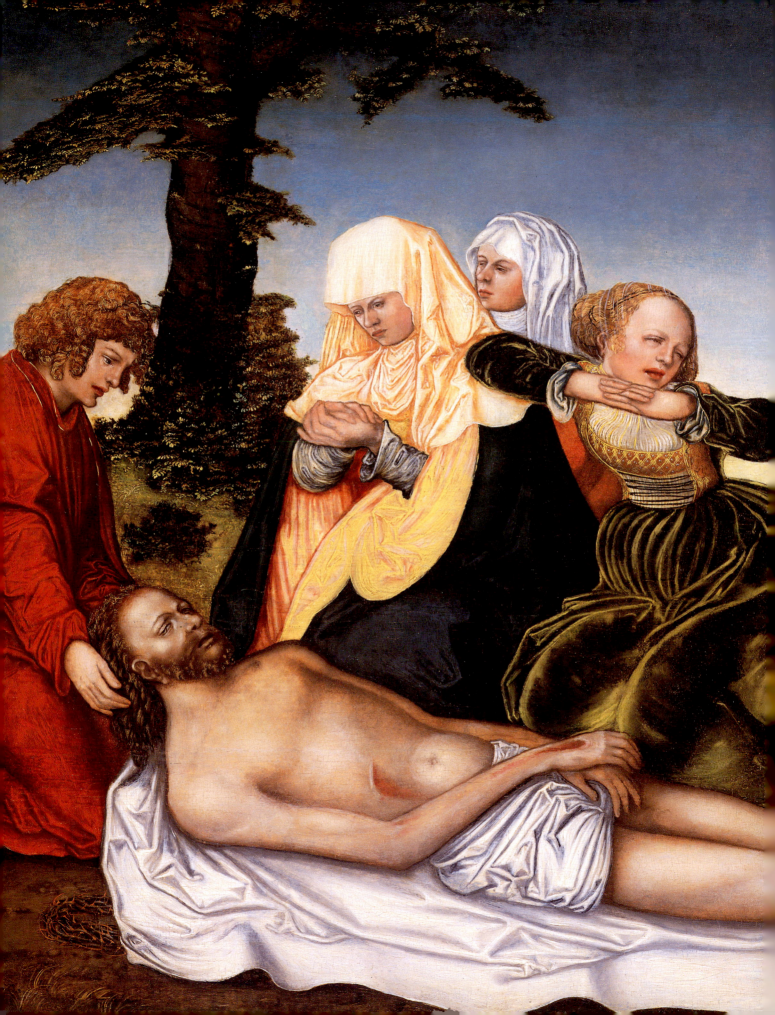

It is a rare privilege to be able to enjoy and savour such inspiring works of art. Amidst the confusion of daily life, war and hunger, disease and disaster, strife and political ambition, the continuing ability of mankind to create, compose, design and write has the capacity to uplift us. This is a welcome reminder when considering the deeper imperatives of our existence; namely that there always emerges great talent, intellect, integrity and honesty. Even in the worst of times, we may discern the best of mankind.

To be in front of El Greco or Turner, to listen to Mahler or Bruckner, to read Dickens or Tolstoy, to look at the Parthenon or the Taj Mahal, to see the Leaves of Southwell or the Lille Donatello, is to reflect on the ultimate supremacy of good over evil.

This exhibition is a part of the collection within our family interests. It is my hope that this collection will remain intact for both personal and public pleasure and enlightenment, recording part of one family's quest, through an exploration of four hundred years or more of artistic talent, for at least some understanding of the human condition.

David Lewis
2010

Introduction

It has often been said that the collecting of Old Master paintings is no longer possible either because so few works are available, or that they are too expensive, except for the richest collectors both public and private. This is not true as so many Old Master paintings are continuously on the art market, especially at auction, but in diminishing numbers with dealers. Further evidence of collecting activity is that many of the public collections in the United Kingdom, both large and small, have been continuously adding to their holdings. Given the will, the private collector can still acquire paintings on the open market although certain fashionable artists remain out of reach for most collectors.

The history of collecting is still in its infancy, especially as so much research is still needed in finding out how and why collectors made their choices. Not all collections were simply accumulations, as many collectors disposed of unwanted works from time to time in order to achieve a certain goal, which would often change as the collector's taste advanced. The Schorr Collection has taken a different point of view as with minor exceptions no pictures have been disposed of and thus the chronology of the collector's taste can be worked out.

The Schorr Collection began with works by the Impressionists, two by Sisley and one by Pissarro, and soon progressed to a broad representation of the Old Masters from the 16th century onwards. What soon emerged was that the collection became representative of several stylistic trends which were defined by 20th century art history such as Caravaggism and Neoclassicism. A parallel interest was in the Netherlandish 16th century which now numbers some 60 works.

The collection therefore soon acquired an historical perspective quite unlike most other collections brought together in the United Kingdom in the last half century. This interest in looking at the Old Masters from an historical point of view and avoiding fashionable trends is not a new one and there are numerous examples from the last two centuries of collecting.

The public collections of the United Kingdom are an unusually rich repository of the Old Masters, even though widely scattered in several hundred small institutions as well as the handful of large ones. Many of these collections are the product of a single benefactor, with the larger ones often showing an accumulation of gifts and bequests, which often differ in type and quality. The reasons behind these benefactions are not always easy to define. For the most part it would seem that collectors wanted to pass on to posterity their own enjoyment, rather than have their possessions scattered by sale, taxation, or dispersed by inheritance to numerous heirs.

Until the 20th century all collections were brought together without the benefit of art historical knowledge, although they now have such strictures imposed on them. As far as can be worked out most of these early collections were based on two broad but interlocking premises, namely personal likes and dislikes and the more rigid canon of taste. Given this lack of academic and intellectual guidance it comes as something of a surprise to note that some collectors from the 18th century onwards seem to have been influenced by other factors. Modern observations on the nature of these early collections have to be somewhat speculative.

Before the foundation of the National Gallery in 1824 with its initial holding of 36 pictures, almost all the earlier benefactions were to existing educational institutions, schools and universities, as there was no concept of a publicly funded art gallery. The earlier benefactions are of some interest, especially that of General Guise to Christ Church College, Oxford in 1765 which contained a serious group of Italian 16th century works. Dr William Hunter gave his miscellaneous collection of modern and Old Masters to the University of Glasgow in 1783, and finally the largest and most significant gift was that of Sir Peter Francis Bourgois to Alleyn's College of God's Gift at Dulwich in 1811. While these collections were essentially heterogeneous they formed part of educational institutions.

The story of William Roscoe in Liverpool is remarkable as he collected with an aim – his Italian pictures were to complement his *History of the Medici*. Roscoe collected pictures which were at the time hardly taken seriously as works of art. This was because they belonged to an earlier period before 1500 when Italian painters were considered of little interest. Today Roscoe's early Italian pictures are considered to range from modest examples of Florentine and Sienese painting to masterpieces by Simone Martini and Ercole de'Roberti.

It is not clear whether Roscoe intended his pictures for permanent public exhibition, but following his bankruptcy in 1816 a number of friends clubbed together and bought some of his pictures at auction and deposited them in the Liverpool Royal Institution in 1819. This meant that Liverpool had on public view a number of Italian paintings which had been brought together for historical reasons, even though as works of art they would have had but little meaning to art collectors of the time.

When the National Gallery was founded there were no such historical principles, as the founding collection, from John Julius Angerstein, contained superb examples of the Old Masters of the 16th and 17th centuries rather than any idea that the pictures should represent the development of European painting. This concept was to come later as the National Gallery expanded in the middle years of the 19th century.

One of the fundamental changes in attitude towards Old Master paintings came with the influence of the writing and lecturing of John Ruskin. Although Ruskin was a complex and self-contradictory character he did believe that paintings were more than objects of beauty. He was violently critical of the then popular Old Masters such as Gaspard Dughet and Meindert Hobbema. He believed in the educational value of pictures and put his theories into practice when he founded a personal museum on the outskirts of Sheffield.

The talisman of the collection was a *Virgin adoring the Christ Child* now attributed to Andrea del Verrocchio. Ruskin believed that by placing an acknowledged masterpiece in a place where there were few other works of art it would have a beneficial effect on the city's workers who could escape from the smoke of their steel works in order to contemplate an exceptional painting.

It is likely that Sir Charles Eastlake was influenced by Ruskinian doctrines as during his directorship of the National Gallery in the 1840s and 1850s many works were added for clearly historical reasons even though they were not strictly fashionable according to early Victorian taste. It has thus become established that there was a legitimacy in the historical approach to public collecting even though the private sector was seemingly unaware of this.

By far the largest collection brought together in the 19th century with the intention of creating a museum was that of John and Joséphine Bowes. They bought exclusively on the French art market from the 1840s onwards, and as their collecting progressed it became obvious that they wanted to represent European painting from the late 15th century onwards. This was in tandem with an even more ambitious buying policy for the decorative arts. This broad scale of collecting has often been a source of misunderstanding about the Bowes collection as neither John nor Joséphine liked to pay high prices, instead they concentrated on the largest number possible of cheaper objects. Modern art historians, in examining the Bowes collection in detail, have proved them right as they were able to obtain significant works from the fifteenth century onwards. At the same time they acquired pictures by living artists who were more avant-garde than conventional. These included pictures by Courbet, Monticelli and Boudin. In recent years the Bowes collection has been rehabilitated and its broad significance has been understood.

One of the least well known of the small historical collections in the 19th century was that put together by Thomas Kay (1841–1914) of Stockport, Cheshire. He catalogued his collection in 1911 before bequeathing it to the art gallery of the Technical School in Heywood, Lancashire. The title page of the catalogue is significant in itself, 'Description of pictures with a short history of anecdotal character intended to illustrate the progress of the art of painting from the Byzantine period to the present day'. Most of the Kay pictures were by minor figures or remain unidentified but one of them described in the catalogue as, "a good example of Byzantine art, probably executed in Italy" has turned out to be by the 15th century Sienese painter, Giovanni di Paolo. The Kay pictures were transferred to Rochdale in 1974 as a result of local government re-organisation.

Perhaps the most recent example of an historically oriented collection to arrive in a public art gallery was the gift of FD Lycett Green to the City Art Gallery, York in 1955. It is said that Lycett Green collected with the intention of presenting his pictures to the National Gallery of South Africa but he changed his mind. The collection covers the Old Masters from the 14th to the 18th century with numerous examples of pictures by artists of great historical importance. To name only a few, the works by Baburen, Melendez and Bellotto appeared less interesting at the time but are now seen to be works of significance in a national context.

The main thread which runs through these collections is one of a certain austerity of taste. This is a direct contrast to the other types of collection which have found their way into public galleries, especially during the 20th century. These collections are easier to like because they contain works of art which are a delight to the senses. Examples of this type are found in the Fitzwilliam Museum in Cambridge with the gift and bequest of 17th and 18th century flower pieces by the 2nd Lord Fairhaven. A second example, less easily accessible, is the Lord Samuel bequest to the Mansion House in London which contains many choice examples of Dutch and Flemish 17th century painting, with a strong emphasis on landscape.

While we may regret that there are not enough 'serious' pictures in these flower pieces or landscape collections, when taken in the general context of public collections they enhance the whole by enlarging the boundaries of taste. Nevertheless, it is the collections which have some historical basis in their make-up which are often the more satisfying. The Schorr Collection belongs to this tradition, but thus far has created a *musée imaginaire* rather than a permanent display.

Christopher Wright
2010

Foreword

This exhibition pays tribute to the visual and intellectual curiosity of a collector whose acquisitions now form one of the largest collections of Old Master paintings amassed in England since World War II. While individual paintings have been widely lent to institutions, this exhibition at the Walker Art Gallery is the first show dedicated to the Schorr Collection.

David Lewis is characteristically modest about the centrality of his role in the development of the Schorr Collection, but this exhibition and catalogue demonstrate the importance of his personal taste and judgement. He began buying art in the early 1970s for family interests. One of the first works bought was by Impressionist artist Eugène Boudin. Other early purchases included Impressionist landscapes. By the 1980s, however, Lewis was developing a unique collector's eye. The result is a collection of great breadth and depth encompassing the Renaissance and Mannerism, the Baroque and Impressionists, and containing many gems such as El Greco's *St. John the Evangelist* and Cranach's *Lamentation over the dead Christ*. Some outstanding aquisitions have been recent, including the Rubens *Allegory of the River God Maranon*.

Alongside well known names, the Schorr Collection includes a delightful number of art historical challenges and mysteries. Lewis buys work that interests him, including works with difficult attributions. The North Italian *Unknown lady* encourages Lewis, and other viewers, to speculate about her identity, engaging with her mystery. As he describes in his opening essay, criteria for entering the collection relate to the appeal of intellectual, emotional or aesthetic factors, and acquisition is not driven by trends or name-checking famous artists. It is particularly refreshing to exhibit these works in an art museum where attribution is traditionally such an important factor in decisions to buy or display. This collection reminds us all that a painting does not need celebrity to be enjoyed.

The Walker Art Gallery, like many other public institutions in the UK and internationally, has long benefited from generous loans from the Schorr Collection. David Lewis believes that art should be made publicly available for all to see whatever their background or circumstances. This contribution to the public good has to date been unpublicised. It is appropriate that the Walker, having benefited from William Roscoe's didactic taste in Old Master paintings, should celebrate philanthropic collecting today.

We are grateful to David Lewis and his family who have not only lent works but played an active role in every aspect of the exhibition. We must acknowledge Christopher Wright, whose knowledge of the Schorr Collection is second to none, Richard Herner, Howard Lewis and Max Plaskow. The catalogue was written by Christopher Wright, with an insightful essay by David Lewis on the development of the collection. Thanks are due to Keith Pointing for its design and layout, Margaret Flood for her work on its preparation, Matthew Hollow for photography and to the Davis Family Interests for their assistance. Our thanks are due to Xanthe Brooke for her selection and interpretation of the 64 works in the exhibition, and to all the staff at National Museums Liverpool who have contributed to the exhibition and this catalogue.

This exhibition is a further step in fulfilling David Lewis' ambition to bring great historic art to the widest possible public. It marks a decades-long commitment to the investigation of art. We think that viewers of the exhibition will be fascinated not only by the paintings themselves but by the reflections in the exhibition on the individual nature of collecting. The Walker Art Gallery is pleased to enable the sharing of this individual passion with a wider audience.

Reyahn King, Director of Art Galleries
National Museums Liverpool

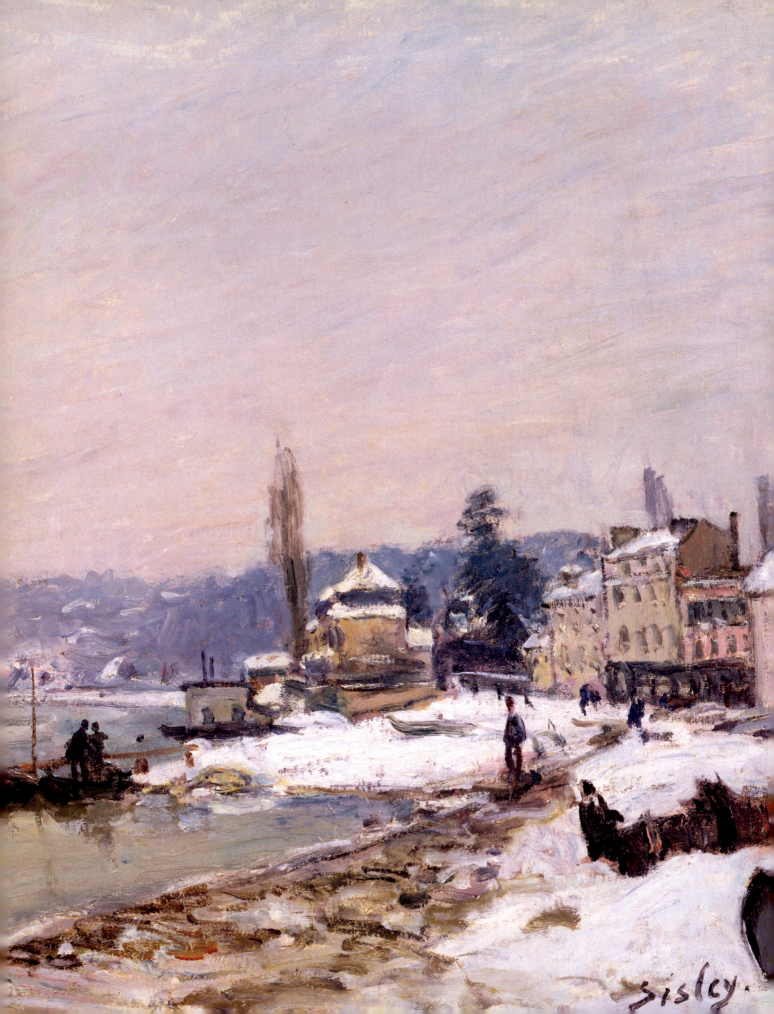

IMPRESSIONISTS

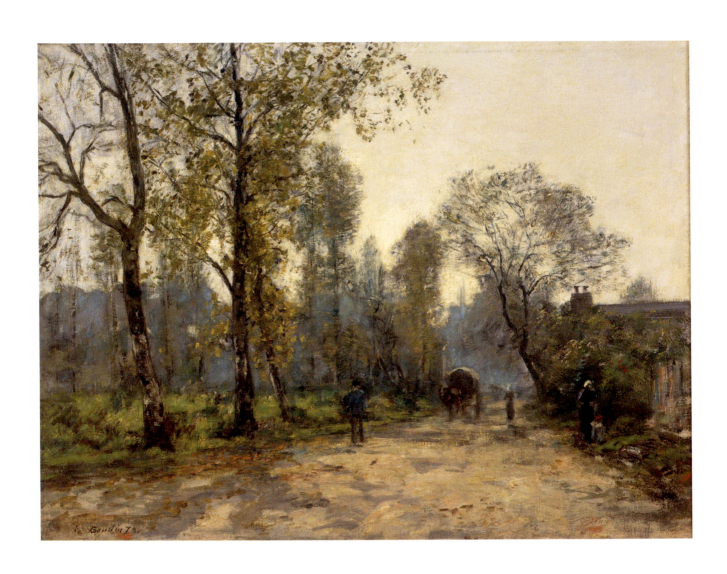

Eugène Boudin

(Honfleur 1824–Deauville 1898)

Le chemin de la Corderie à Trouville

Oil on canvas 40 x 55 cms

Painted in Trouville 1873

Trouville, along with neighbouring Deauville, was one of the most popular locations for Boudin to work on his beach and coast scenes. Both places had become fashionable resorts especially for Parisians as both towns were then connected directly to Paris by railway. The Empress Eugénie herself favoured the area as shown by Boudin's painting of her on the beach at Trouville in the Burrell collection in Glasgow.

Boudin's position as an innovator has been reassessed in recent years and he is now seen as an important precursor of the Impressionists who were directly influenced by him, especially Claude Monet, whom he met in 1858. Boudin spent most of his long career at Le Havre and most of his subject matter derives from that locality or the other side of the Seine estuary in and around his native Honfleur. He also visited other towns in search of fresh subject matter, as

seen in his views of the ports of Bordeaux and Antwerp. The essence of Boudin's style was to capture the fleeting qualities of nature which he found best on a small scale. He took part in the first Impressionist exhibition in Paris in 1874. Later in his career his pictures suddenly became fashionable in the wake of the discovery of Impressionism, and in 1886 his first picture was bought by the French State. Because of the way Boudin sought to record certain moods of nature, there was a tendency for his pictures to be repetitive.

However, in the large collection of his pictures in the Musée des Beaux-Arts at Le Havre, it is possible to see how far from the conventions of his time he had gone, especially in his rapid studies of figures on the beach.

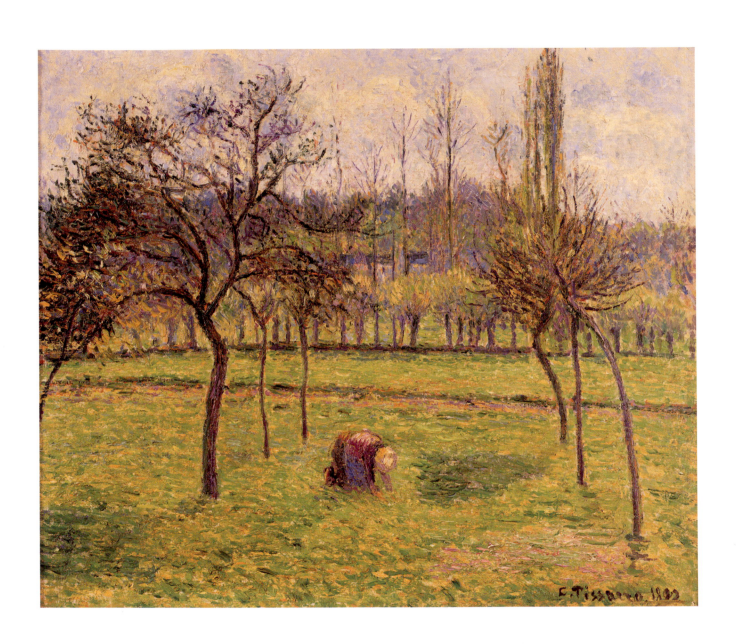

Camille Pissarro

(Charlotte Amalie, St Thomas (Danish Virgin Islands) 1830–Paris 1903)

Pommiers dans une prairie

Oil on canvas 46 x 55 cms

Painted in Eragny in 1892

In his later years, Pissarro used a distinctive style which set him apart from his fellow Impressionists. His lighting became softer and his tones much closer together. This reflects the feel of the local countryside, but only at certain times of the year. The figure seems to blend into the landscape.

Pissarro, born a Danish citizen, seems to have been more restless than his fellow Impressionists. Ten years older than Monet, his first influence seems to have been Corot. After a peripatetic youth, which included a visit to Caracas in Venezuela, Pissarro finally settled in France in 1855. He worked in Montmartre but favoured various places to the west of Paris, including Montmorency, Varenne-Saint-Hilaire, Pontoise and finally Louveciennes which he was forced to leave in September 1870, owing to the advancing Prussian troops. His rented house there was used as a billet by the German soldiers and, by his own account, Pissarro lost twelve hundred paintings, drawings and sketches, although some forty were saved.

As with Monet, Pissarro's exile in London proved fruitful because it brought him in contact with the work of Turner. Returning to France in 1871, Pissarro settled at Pontoise until 1882, when he moved to Osny. The last place he worked in was the small village of Eragny-Bazincourt, near Gisors. He spent the winters in Paris and travelled to other major towns, favouring Rouen. Pissarro's brand of Impressionism was for the first part of his career heavily influenced by Corot. For a short period in the 1870s, Pissarro's work was mainstream Impressionist but he changed quite dramatically with the evolution of pointillism under Seurat. His later style, therefore, became a mixture of essentially conflicting styles. Nevertheless, Pissarro always referred back to nature and some of the late views of Paris are his best works. More than the other Impressionists, Pissarro was capable of subtle social comment in his work. There are more labourers, factories and figures in general than found in the much sunnier Sisley and Monet.

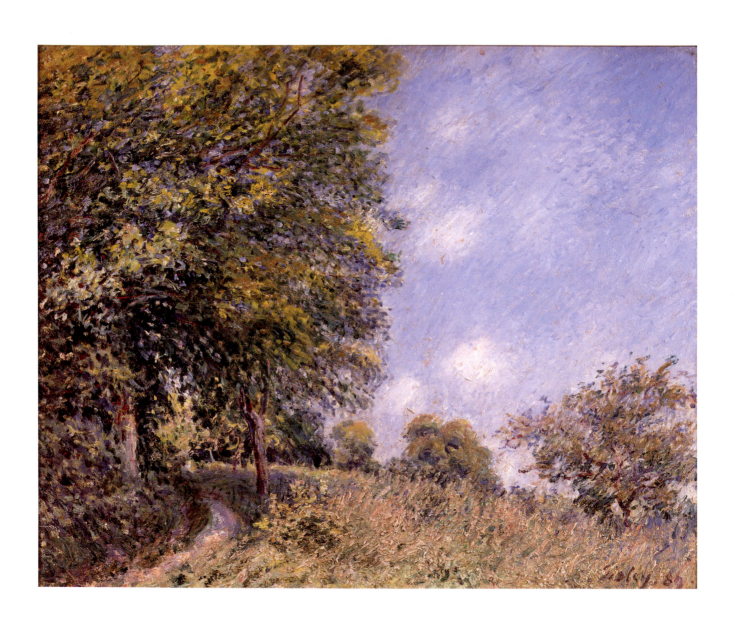

Alfred Sisley

(Paris 1839–Moret-sur-Loing 1899)

Autour de la forêt, matinée de juillet

Oil on canvas 60 x 73.5 cms

Painted in Moret-sur-Loing in 1889

In this composition, Sisley has used a very high key of colour. Weather effects of this type only existed for the short summer season, and are in any event quite unlike the Mediterranean light so often favoured by Monet. The exact site has not been identified, but it is probably on the edge of the forest of Fontainebleau as Sisley was spending time there in 1889.

Sisley spent most of his life in France, apart from visits to England. Of English parentage, he was never naturalised French but in every other respect the formation of his art was entirely French. At the time of his work in the studio of Gleyre in 1862, he knew Monet, Renoir and Bazille and this acquaintance and friendship remained for the rest of their lives. Along with Monet and Pissarro, Sisley spent the Franco-Prussian war, 1870–71, in exile in London where he inevitably came into contact with the work of Turner. Most of Sisley's career was spent in the villages or suburbs around Paris, first at Louveciennes and later at Marly and Sèvres, and in 1879 he moved to Moret-sur-Loing where he spent the rest of his life. The church at Moret became one of his favourite subjects and Sisley painted it in changing light and weather with as much affection but less éclat than Monet was to do at Rouen. Of all the Impressionists Sisley was the most consistent, his style evolving but slowly. His early work was strongly influenced by Gustave Courbet.

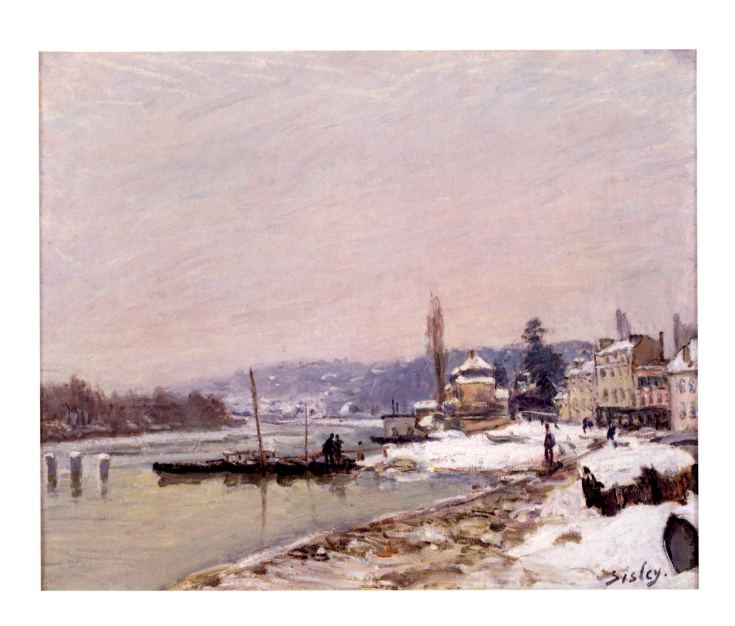

Alfred Sisley

(Paris 1839–Moret-sur-Loing 1899)

Port-Marly sous la neige

Oil on canvas 46 x 56.5 cms
Painted in Port-Marly in 1875

Port Marly occupied Sisley as a main subject in the 1870s. It was in 1876, the year after this winter scene was painted, that he produced the famous *L'inondation à Port-Marly* (Paris, Musée d'Orsay). Many of the artist's snow scenes date from the 1870s. In this example, the tonalities are particularly subtle, as the snow takes on nuances of light and colour which have been caught perfectly by the artist. The exact site is a view looking up the River Seine towards Bougival with the village of Port-Marly on the right. It is recorded that the winters of 1875 and 1876 were unusually harsh, and the prolonged period of snow gave Sisley the opportunity to observe its effects.

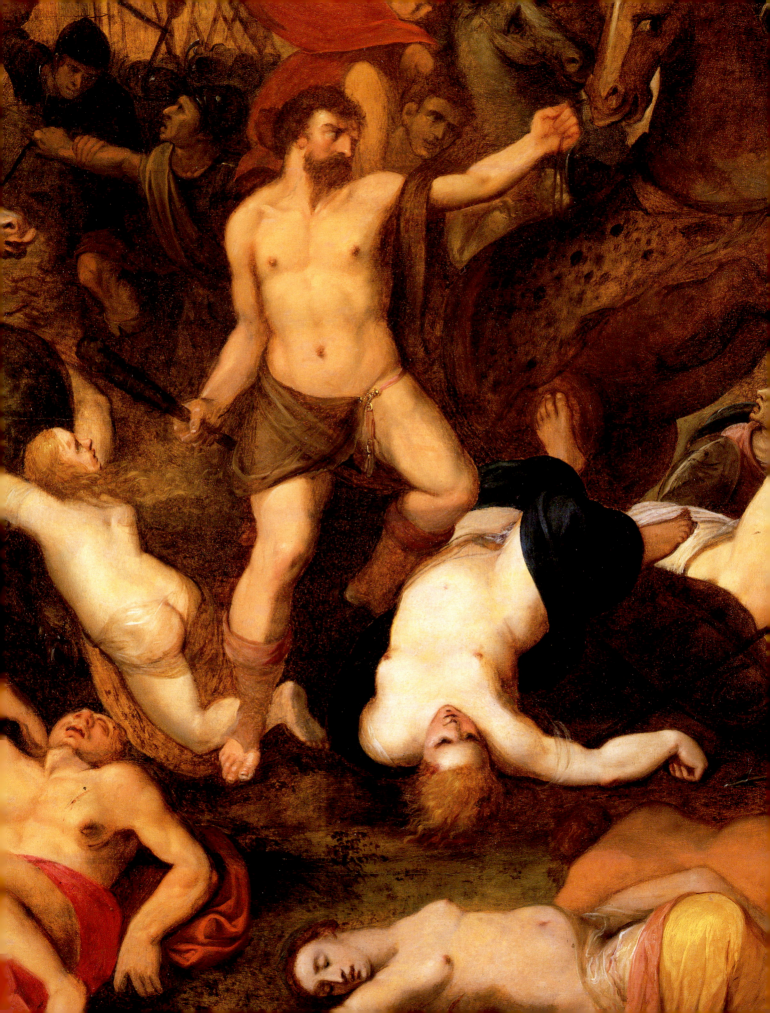

15TH AND 16TH CENTURIES

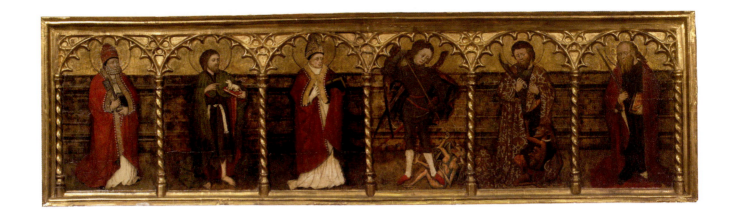

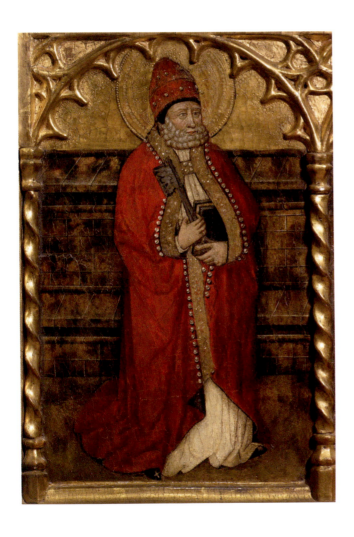

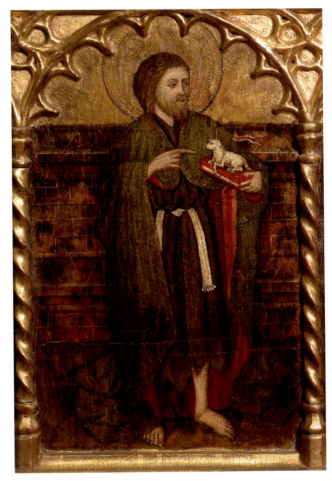

Spanish School

(Catalan, mid 15th century)

St. Peter, St. John the Baptist, St. Augustine, The Archangel Michael, St. Bartholomew and St. Paul

Oil on panel 41.5 x 170 cms

Painted in Catalonia mid 15th century

The saints are depicted in their standard late-medieval forms. St. Peter is seen in his robes as First Bishop of Rome, holding the symbolic keys given to him by Christ. St. John the Baptist holds the Mystic Lamb of God and is shown barefoot, symbolic of his sojourn in the wilderness. St. Augustine appears as one of the Four Doctors of the Church, correctly mitred. The Archangel Michael is shown vanquishing the devil, whilst St. Bartholomew holds the knife with which he was martyred. St. Paul is seen with his sword of Martyrdom and his Epistles. The whole emphasis is on the richness of Saint Paul's apparel, and even the normally austere St. Bartholomew is shown in an elaborately decorated robe. It is certain that this series of saints with their gilded tracery work comes from a very much larger complex and probably forms part of the predella. Large scale painted altarpieces were very popular in late medieval Spain. These were often composed of dozens of panels of differing sizes with gilt backgrounds and gothic tracery work. Some of these survive in situ, especially in Catalonia. A rare example of such a complete altarpiece outside Spain is the *Altarpiece of St. George* attributed to the 15th century Valencian painter, Marczal de Sas (working 1420s), in the Victoria and Albert Museum, London.

Top: Complete work

Below: Details of work; St. Peter, and St. John the Baptist.

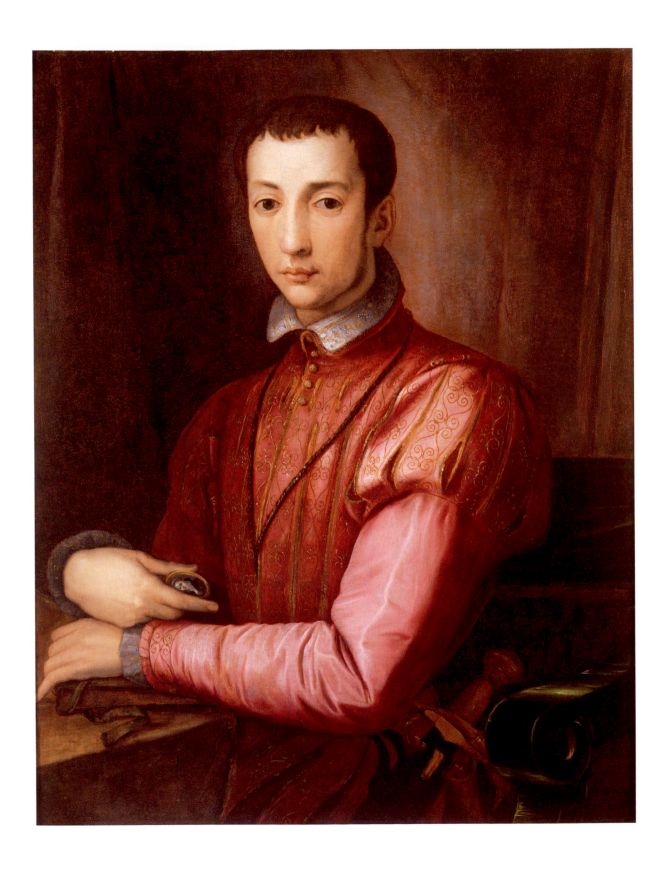

Alessandro Allori

(Il Bronzino)

(Florence 1535–Florence 1607)

Portrait of Francesco de' Medici (1541–1587), Grand Duke of Tuscany, from 1574

Oil on panel 87.5 x 69.5 cms

Painted in Florence, about 1560

This portrait depicts the sitter at the age of about twenty. The miniature he holds has been identified as that of his sister, Lucrezia (1545–61), who was married by proxy to Alfonso II, d'Este, Duke of Ferrara, in 1558. The marriage was consummated when the sitter accompanied his sister to Ferrara in 1560. It has been generally assumed that the versions of this picture both by Allori and other artists, were executed at about this time. Francesco de' Medici was the son of the great Cosimo I de' Medici and Eleanora da Toledo, both of whom were memorably painted by Bronzino. Francesco was a very different character from his energetic and charismatic father. Francesco's short reign was characterised by his interest in architecture and painting, and his main court artist was Allori, although he also used Maso da San Friano (1531–71) and Hans von Aachen. Francesco was also painted by Bronzino when he was a boy (Florence, Uffizi)

and possibly again as a young man with a light growth of moustache and beard (Florence, Museo Stibbert).

Allori was the leading Florentine painter of the second half of the 16th century, succeeding Bronzino as the main recipient of Medici commissions. Allori's style was largely based on that of Bronzino, whose pupil he was. Allori spent the years 1554–60 in Rome where he was influenced by the later work of Michelangelo. On his return to Florence, Allori continued Bronzino's court style for the next fifty years. Far more prolific than Bronzino, he executed many portrait commissions and produced a number of small subject pictures. By the end of his career in about 1600, his style was already out-of-date and heralding a time when the dominant patronage of the Medici would be much diminished.

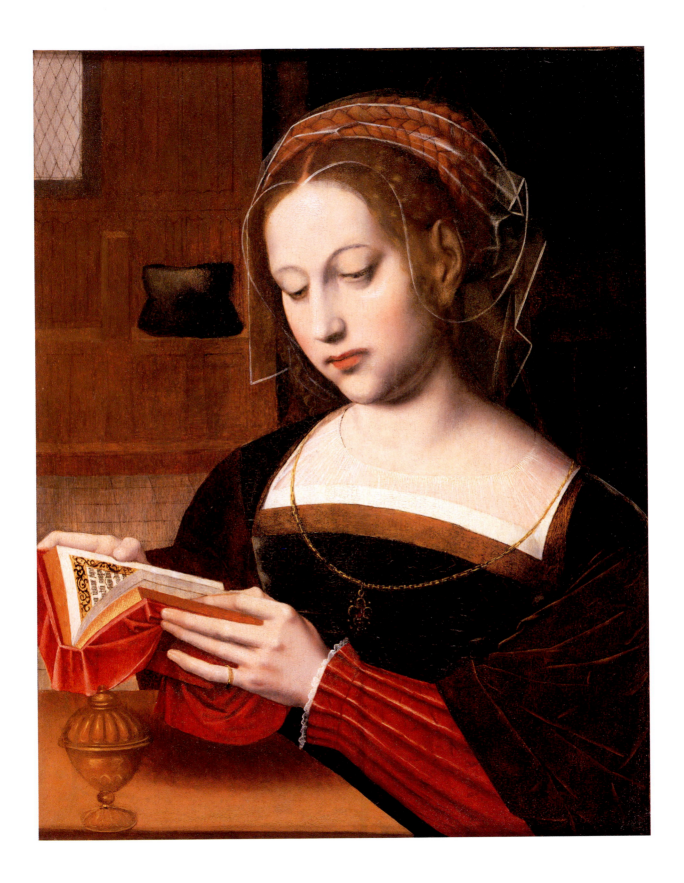

Workshop of Ambrosius Benson

(Born Lombardy, date unknown, working

about 1519–died Bruges 1550)

The Magdalen reading

Oil on panel 52.2 x 41 cms

Painted in Bruges, about 1520

The cult of the Magdalen was especially popular in the Middle Ages and the Renaissance, with the Gospel stories being elided to create the two main types favoured by painters and their patrons. The first, more frequent in the Baroque depicts the Magdalen repenting her sins after a life of luxury. The second, favoured earlier, shows her serenely reading, with the symbol of the alabaster box of ointment, with which she had anointed Christ's feet. *The Magdalen reading* was one of Benson's most often repeated themes, many of them differing considerably from each other, which further emphasises the extent of workshop activity. Exactly as with the St. Jerome there is consistency of quality in the works.

Ambrosius Benson, of Italian origin, was recorded in Bruges working with Gerard David from 1519 onwards. His 30 year long career there has allowed a large number of paintings to be attributed to him. It is likely that Benson headed a prolific workshop, rather similar to that of Isenbrandt (see page 53). However, unlike the workshop pictures associated with Jan Gossaert or Marinus van Reymerswaele (see page 69), there was a consistent standard, which suggests at least some supervision by the Master. Only two pictures bear monograms considered to be Benson's and Benson's oeuvre is therefore not fully distinct. His pictures have often been confused with the equally nebulous Adriaen Isenbrandt. Nevertheless, Benson and Isenbrandt together reflect the late flowering of the Bruges school, with its distinct soft edges, gentle expressions, and warm colouring.

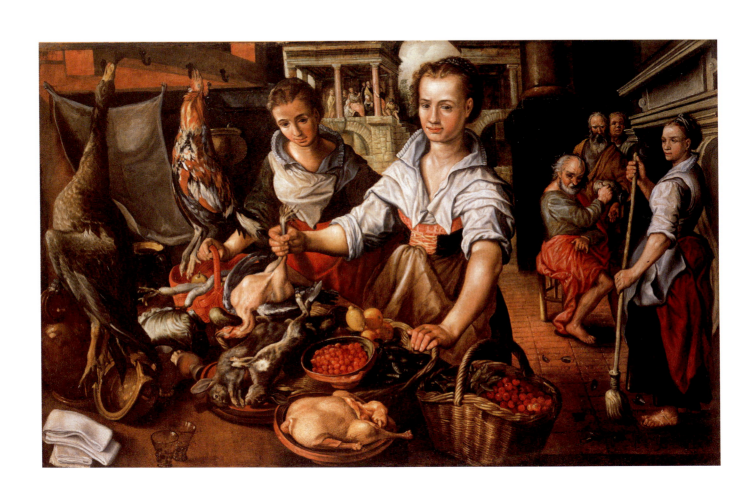

Joachim Beuckelaer

(Antwerp about 1533–Antwerp about 1574)

Christ in the House of Martha and Mary

Oil on panel 112 x 177.3 cms

Painted in Antwerp, about 1565

This subject is one of the most repeated in Beuckelaer's work as it is in Pieter Aertsen's. Christ is in the house of Martha and Mary (from St. Luke's Gospel) where Mary listened to Jesus' word while Martha did the serving. When Martha rebuked Jesus he reminded her that Mary was right to listen to him. As in the Aertsen, the picture is essentially a genre piece with the religious subject matter placed in the centre background. Even the composition is dependent on Aertsen, although Beuckelaer subtly changes the emphasis of the still life elements.

All Beuckelaer's surviving output keeps to the same style and subject matter, with large figures in interiors or at market. These pictures were so influential on 17th century Netherlandish painting that they now seem familiar even though they were innovative at the time. Although sometimes derived from the artist's master, Pieter Aertsen, Beuckelaer's originality is obvious in the freshness and directness of his treatment of everything from fish and vegetables to the tiny (and often significant) figures in his background. Details of Beuckelaer's life are curiously scant, especially as he seems to have worked all his life in Antwerp. He was enrolled in the Guild there in 1560 and is recorded as having had a pupil in 1573. Van Mander, writing in 1604, praised Beuckelaer for his ability to depict birds and fish but also remarked that the artist received relatively low payment for his work. It is only since the beginning of the 20th century that his importance in the development of 16th century painting has been recognised. Recent research has now identified the work of Beuckelaer's younger brother Huybrecht (working Antwerp from about 1563 until after 1584) who adapted Joachim Beuckelaer's distinctive style by changing the facial expressions into something sweeter and less robust. In all other respects Huybrecht's work resembles that of his brother, especially in the freedom of handling and composition.

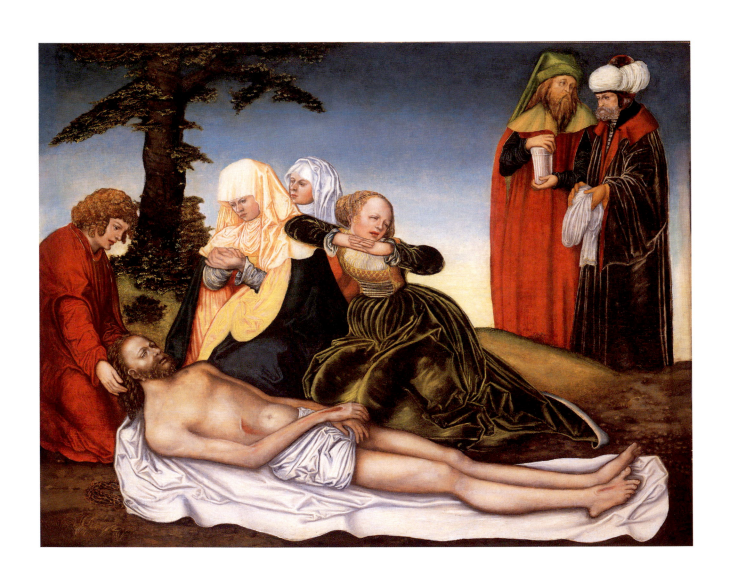

Lucas Cranach

(Kronach about 1472–Weimar 1553)

Lamentation over Dead Christ

Oil on panel 74.2 x 97 cms

Painted Weimar, about 1520

Cranach's rather stiff approach to the subject, with the hieratic poses is based on the influence of late medieval sculpture, where the main figures are grouped to form the maximum dramatic effect. The facial expressions are also reminiscent of German late gothic sculpture, which reached a high point with such artists as Tilman Riemenschneider (about 1460–1531).

Lucas Cranach's long career, mostly working for the Protestant Electors of Saxony, is seen to capture the transition from Gothic to Renaissance art in the German speaking world. Cranach's artistic origins are unknown, his earliest works dating from about 1502 owing much to the Southern German tradition centred round Munich. Cranach first starting working for the Elector Frederick the Wise in Wittenberg in 1505. In 1508 Cranach visited the Hapsburg Netherlands, where he painted the future Emperor Charles V in Mechelen (picture now lost). Cranach came under the influence both of Jan Gossaert and Quentin Metsys.

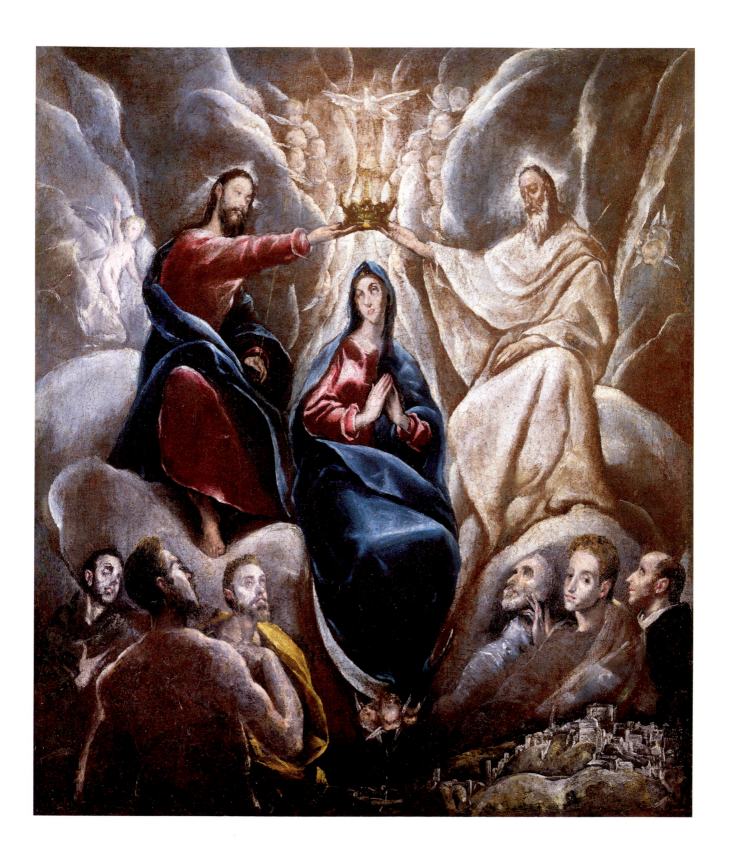

El Greco
(Domenikos Theotokopoulos)
and studio

(Candia (Herakleion), Crete 1541–Toledo 1614) and studio

The Coronation of the Virgin

Oil on canvas 60.7 x 52.7 cms

Painted in Toledo, about 1591

The composition by El Greco himself is known from an altarpiece painted by El Greco in 1591 for the church of Talavera la Vieja near Toledo, which was destroyed in the Spanish Civil War in 1936. Three canvasses survived however, the central one from the upper part of the altarpiece being *The Coronation of the Virgin*, now in the Museo de Santa Cruz, Toledo. There are numerous differences between this Schorr canvas and the Toledo work, especially in the disposition of the saints who occupy the lower part of the composition in both pictures.

The upper part in the two pictures is much more similar, except for the difference in scale. In the Schorr picture, the cleaning revealed that the three figures on the right were floating above a view of Toledo which had been entirely overpainted. The integration of a view of Toledo and a *Coronation of the Virgin* occurs in El Greco's related *Coronation of the Virgin* in the chapel of San Jose, Toledo, which also dates from the 1590s.

In spite of great deal of research over the last hundred years, relatively little is known about El Greco's career before he arrived in Toledo, Spain, in 1577 at the age of 36. His stylistic origins were certainly Byzantine icons, then still current in his native Crete. The artist's Italian sojourn is virtually undocumented but he is considered to have been a pupil of Titian in Venice in the 1560s. El Greco's Venetian period pictures, which are mostly portraits, also show the influence of Tintoretto, as well as Leandro and Jacopo Bassano. El Greco's distinctive style developed on his arrival in Spain with its exaggeration of perspective, form, colour and human expression. The artist was successful in receiving commissions to paint altarpieces and sets of Apostles for the churches and convents of Toledo and elsewhere in Spain. In the 17th, 18th and early 19th centuries, El Greco's work was virtually forgotten, but by the early 20th century his reputation had grown so much that he was placed amongst the greatest of Renaissance masters.

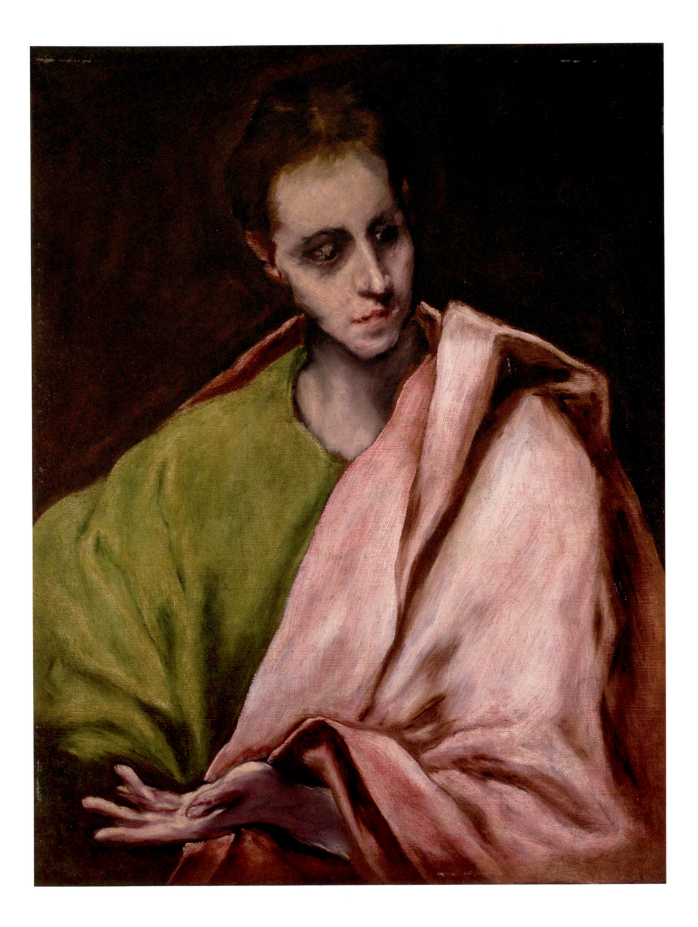

El Greco

(Domenikos Theotokopoulos)

(Candia (Herakleion), Crete 1541–Toledo 1614)

St. John the Evangelist

Oil on canvas 71.5 x 55 cms

Painted in Toledo, probably 1613–14

This haunting picture has all the characteristics of El Greco's late style, so clearly seen in the way the Saint's features seem slightly out of focus while at the same time producing a feeling of movement. Although now in isolation, his sets of apostles were carefully coordinated to allow the strong colours of the draperies to create a dramatic chromatic effect. The *St John the Evangelist* comes from one of the series of apostles painted by El Greco for which there is evidence of at least five. Nine canvases survive from this particular series. They were discovered in a remote church in Almadrones, during the Spanish Civil War in the 1930s and five of them were sold by the Spanish Government after 1945.

The remaining four pictures, which are probably not by El Greco, were retained by the Spanish State and placed in the Prado, Madrid. The other five pictures, including this one, all went to American collections; three to the Clowes Fund Museum in Indianapolis, one to the Los Angeles County Museum and this one to the Kimbell Art Museum, Fort Worth, but was later deaccessioned.

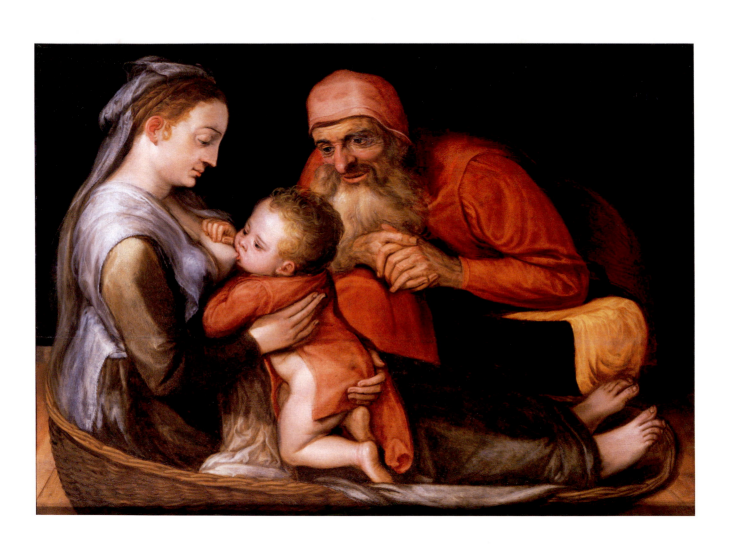

Frans Floris
(Frans de Vriendt)
(Antwerp 1515-20–Antwerp 1570)
Holy Family
Oil on panel 81 x 111.5 cms
Painted in Antwerp, 1550s

This picture is very freely painted, as is so often the case in Floris' smaller works. It is likely that the painting is a preparatory study for the much larger and more detailed work, also signed, in the Musée de La Chartreuse at Douai. The intimacy of the scene shows a new informality in the painting of religious devotional works. Instead of the idealised tradition of the 15th century, the artist has imagined Joseph as a busy old man and the Virgin and Child as an ordinary couple, all three in very obviously humble circumstances. The free technique allows us to see Floris' working methods which were almost impressionistic in their approach. Many such pictures were lost in the iconoclastic crisis of the 1560s.

Frans Floris has always been recognised at the leading painter in Antwerp in the middle years of the 16th century, and for the whole of the second half of the century he was the most influential of all Northern artists. His early formation was with Lambert Lombard in Liège in the period around 1538–40. This was undoubtedly an influential period in his development even though current scholarship cannot agree which pictures, if any, survive from Lombard's own hand in this period. Floris was recorded in the Antwerp Guild in 1540–41. He then went to Italy and did not come back to Antwerp until in or before October 1547. Floris' achievement as a great master is seen in the *Fall of the rebel angels* painted for Onze Lieve Vrouwekerk in Antwerp in 1554 (Antwerp, Koninklijk Museum voor Schone Kunsten). Floris was one of the few Netherlandish artists of his time who could absorb the lessons of both Raphael and Michelangelo without being dominated by them. On some occasions, Floris' freedom of brushwork and facility of drawing was not rivalled until Rubens (see page 71 and pages 121–3) in the next century. On the other hand, this freedom was not above contemporary criticism and Van Mander quoted an uncomplimentary ode to Floris written by Dominicus Lampsonius (1532–99); 'Had you painter Floris, been as fully devoted to art/As you were by natural talent abundantly equipped to be/Since you are more inclined towards making many things rather than spending time on it/And since the regular employment of the file and laborious work does not appeal to you/Then I would call out: Yield painters from whichever country you hail,/whether you were born in olden days or present times'. Wilenski lists a large number of Floris' pupils which included Crispiaen van den Broeck, Maerten van Cleve (1527–81), Hendrick van Cleve (1525–89), Lucas de Heere (1534–84), Hieronymus Francken the Elder (about 1540–1610), Ambrosius Francken, Frans Francken the Elder (1542–1616), Frans Pourbus the Elder (1545–81) and Maerten de Vos (1532–1603). However, Van Mander lists no fewer than thirty pupils.

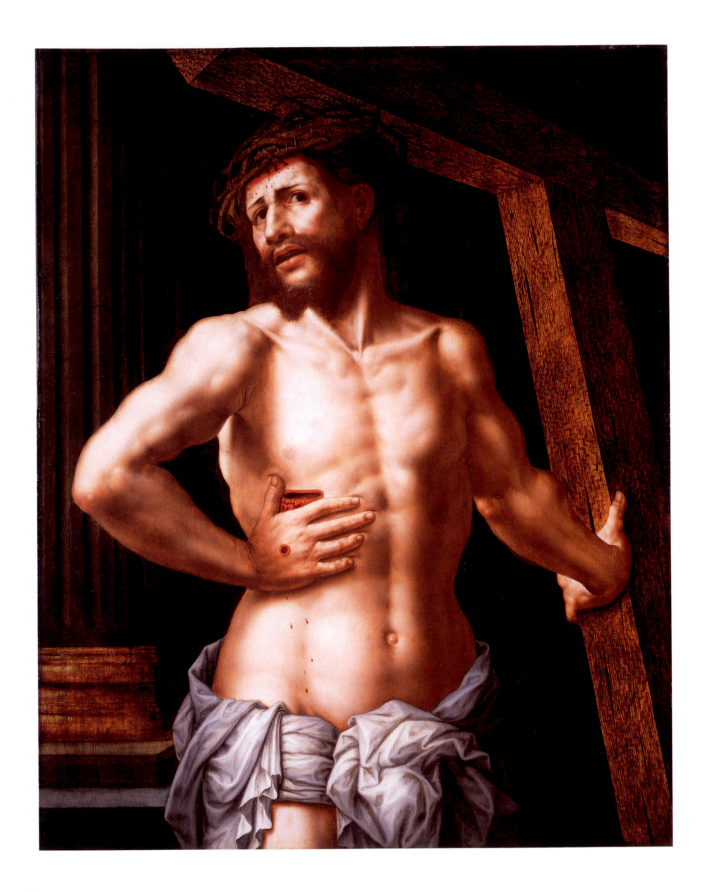

Jan van Hemessen

(Hemiksem about 1500–Haarlem about 1556)

Christ as the Man of Sorrows

Oil on panel 108.2 x 85.5 cms
Painted in Antwerp, about 1540

This is one of Van Hemessen's most haunting images, a mixture of inspired rigour of drawing combined with great pathos of expression. Christ is shown exposing the wound inflicted by the centurion's lance. The closely-related version at Linz is dated 1540 and it is therefore likely that this picture comes from approximately the same time. As in most of Van Hemessen's compositions there is great originality of approach as the artist gradually abandoned the equilibrium of the Netherlandish style. In its intensity the picture rivals the treatment of the same subject by Antonello da Messina.

Unusually for an Antwerp artist of his time and calibre, Van Hemessen was not given a biography by Van Mander, and was merely mentioned in passing. 'In Haarlem too there was in earlier days Jan van Hemsen, a citizen of that town, whose working method was more approaching the ancients, somewhat different from the moderns. He painted large figures and was in some respects very neat and precise. There is a piece by his hand with many Apostles standing next to Christ who are about to go to Jerusalem. This is in Middelburg at the house of the art lover, Mr. Cornelis Monincx': (translation by Hessel Miedema). Van Hemessen's career was only reconstructed in the late 19th century by the examination of records and the study of signed paintings. The artist was apprenticed in Antwerp in 1519 and became a master in the Guild there in 1524. He was last recorded in Antwerp about 1555 and there are signed and dated paintings ranging from 1531–57. In the early stages of his rediscovery, some historians had wrongly identified him as the Brunswick Monogramist. Van Hemessen was a highly original artist in the exaggeration of both poses and expressions in his models. This produces a form of extreme emotion which, coupled with his strongly linear style, puts Van Hemessen slightly outside the mainstream of Antwerp painting of the time. The artist who most nearly approaches him is Jan Massys.

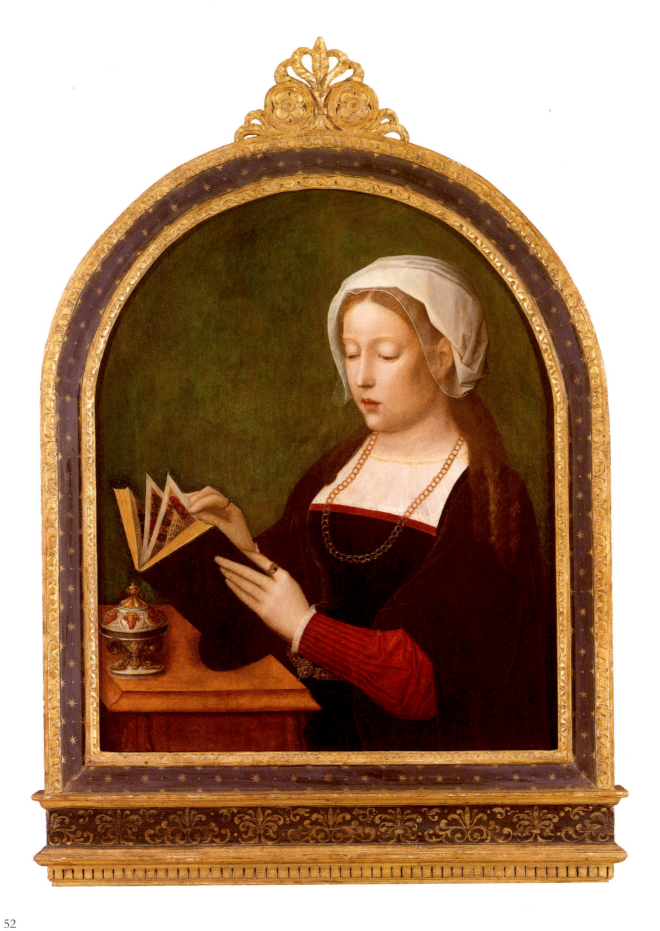

Adriaen Isenbrandt

(working Bruges 1510–died Bruges 1551)

The Magdalen reading

Oil on panel 78 x 64.5 cms

Painted in Bruges, about 1510–20

The treatment of the subject is exactly the same as the rather similar work by Ambrosius Benson (see page 39). This composition was one of the artist's most favoured subjects with several high quality repetitions. As is usually the case with Isenbrandt, there are subtle variations between each treatment of the subject. The artist continued to change the details of the clothes, jewellery and the exact positioning of the devotional book held by the Magdalen. Most pictures of this type were painted for private devotion and a large number have survived with examples by almost all the major artists of the period.

The work of Isenbrandt was first identified by the pioneering Belgian scholar, Hulin de Loo, at the time of the exhibition of early Flemish Primitives organised by him in Bruges in 1902. The altarpiece of the Seven Sorrows of the Virgin, (the Van de Velde diptych) divided between Bruges, Onze Lieve Vrouwekerk, and Brussels, Musées Royaux des Beaux-Arts, formed the basis of Hulin de Loo's definition of the then elusive Isenbrandt. A surprisingly large corpus of pictures is now grouped round this celebrated altarpiece, rising in recent years to a total of some five hundred. However, Lorne Campbell (Catalogue of the Early Netherlandish Paintings in the Collection of Her Majesty The Queen, Cambridge, 1985, page 126), suggested that this altarpiece could be attributed to Aelbrecht Cornelis, (working Bruges 1513 – died Bruges 1532). Campbell also pointed out that more than one workshop may have been involved.

A few documents survive concerning Isenbrandt's life but nothing about his paintings of which none is either signed, dated, or documented. Isenbrandt married twice and held various offices in the Bruges Guild of St Luke. He was first mentioned in Bruges in 1510, but his career has to be reconstructed entirely on stylistic grounds but on the basis of only a few clues. The artist has always been associated with the Bruges master, Gerard David (died 1523) since many of the pictures given to him are close in style, mood and composition to the late work of David. The latter artist's precision and clarity were gradually abandoned by Isenbrandt when he introduced a Leonardesque sfumato which seems to envelope many of his later pictures. At the same time, Isenbrandt's approach occasionally approximated that of Ambrosius Benson often sharing an interest in the same subject matter and format of composition, as is seen here in Isenbrandt's and Benson's *Magdalen reading*.

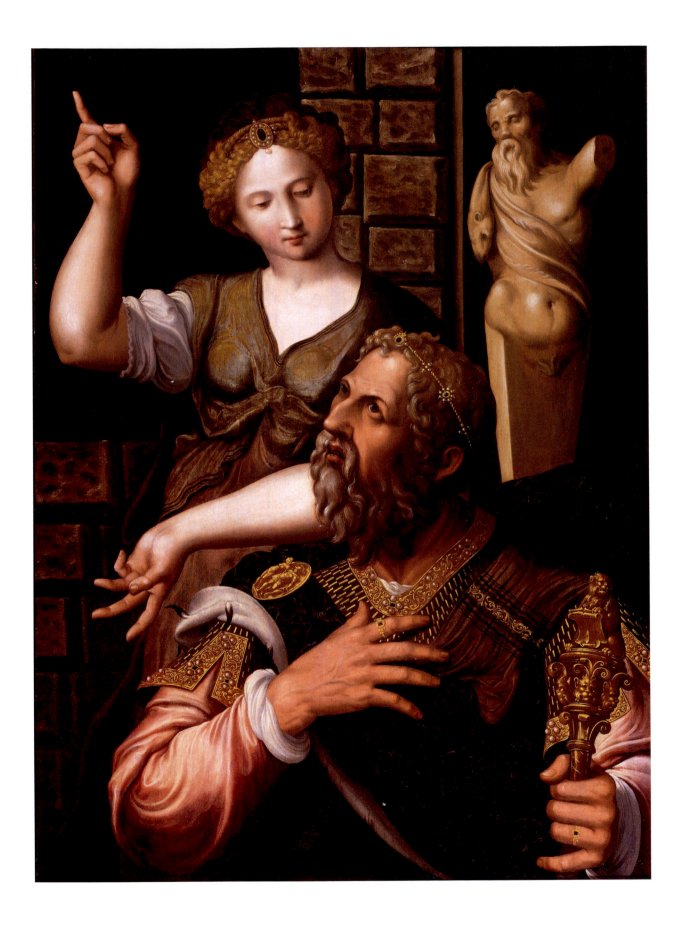

Pieter van Kempenaer

(Brussels 1503–Brussels after 1580)

Augustus and the Tiburtine Sibyl

Oil on panel 111 x 82 cms

Painted in Brussels, early 1530s

In general style, this picture is strongly Italianate showing the influence of the Italianising Barent van Orley to whom it had previously been attributed. This would suggest that the painting is a relatively early work, from the 1530s before the artist arrived in Spain in 1537. The Tiburtine Sibyl was the tenth and last in the group of ancient Greek figures. Curiously enough, they became part of Christian mythology.

The Roman Emperor Augustus (63 BC–14 AD) had been declared a living god by the Roman Senate. The Emperor then consulted the Sibyl who predicted the birth of Jesus Christ, and at the same time a heavenly vision of the Virgin and Child opened up to the pagan Emperor. This mythical incident was taken up by Christian artists and writers, and became popular with Renaissance painters.

Van Kempenaer's long career spanned most of the 16th century. He was distinguished early on in creating a triumphal arch in Bologna for the Coronation celebrations of Emperor Charles V in 1530. By 1537, he was in Seville, Spain, where he was to remain until 1562. A very high proportion of the artist's surviving work is in the churches of Seville, and he is usually regarded as a Spanish artist, even though his artistic style remained essentially Flemish but under Italian influence. Van Kempenaer was also a sculptor and an architect, and in 1563 he succeeded Michel Coxcie, who retired to Mechelen, as director of the tapestry factory in Brussels. The artist also seems to have been closely connected with Barend van Orley, presumably in Van Kempenaer's early years in Brussels, before 1530.

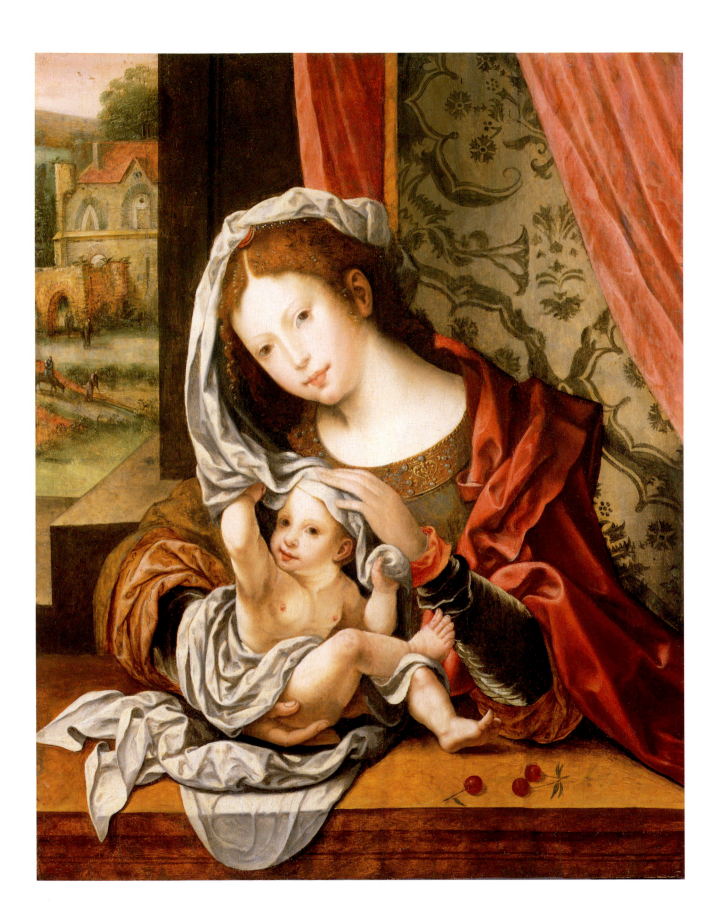

Master of the Prodigal Son

(working about 1530–about 1560)

Virgin and Child

Oil on panel 69 x 54.5 cms

Painted in the Southern Netherlands, probably 1530s

This composition was repeated by Jan Gossaert, his studio and his followers in other workshops, on no fewer than 50 surviving occasions. Friedländer believed that Gossaert himself created an original composition from which all the others were derived, but this hypothesis was tested recently when the signed painting, which was in a Stuttgart private collection in the 1930s, appeared in a London sale room in 2005. This composition had every appearance of being an adaptation by a workshop other than that of Gossaert himself, and the date of 1550 on the painting confirms this. The attribution of the version here to the Master of the Prodigal Son is based on comparison with other versions of the composition, where there is a distinctive landscape background. The tradition of depicting the Virgin in an interior looking out onto a landscape or urban background was strong in the Netherlands in the 15th century, but by this time it had become somewhat diluted as artists sought to be more inventive in the way they depicted the figures. The use of the ledge in the foreground is also derived from the 15th century tradition.

The paintings attributed to Master of the Prodigal Son consist of a small group of paintings associated with a *Story of the Prodigal Son*, in the Kunsthistorisches Museum, Vienna. The Vienna painting is generally considered to have been executed in Antwerp in the second third of the 16th century. It was originally thought that this anonymous artist may have been Jan Mandyn, who is now seen as a follower of Hieronymous Bosch (about 1463–1516). A further candidate was Lenaert Kroes, from whose hand no pictures have been certainly identified. However, many of the pictures currently associated with the Master of the Prodigal Son were formerly attributed to Pieter Coecke van Aelst. Currently, the list of paintings convincingly attributed to this Master include, *The Parable of the Source* and *Lot and his daughters* (Antwerp, Koninklijk Museum voor Schone Kunst), a *Virgin and Child* (Berlin, Gemäldegalerie), *A Court of Miracles* (Brussels, Musées Royaux des Beaux-Arts), *Triptych: Lamentation over Dead Christ* (Cologne, Wallraf-Richartz Museum), *Virgin and Child* (Lille, Musée des Beaux-Arts), *Elijah fed by the raven* (Utrecht, Catherijneconvent), *The Works of Mercy* (Valenciennes, Musée des Beaux-Arts) and *Christ and his Disciples on his way to Emmaus* (Warsaw, National Museum).

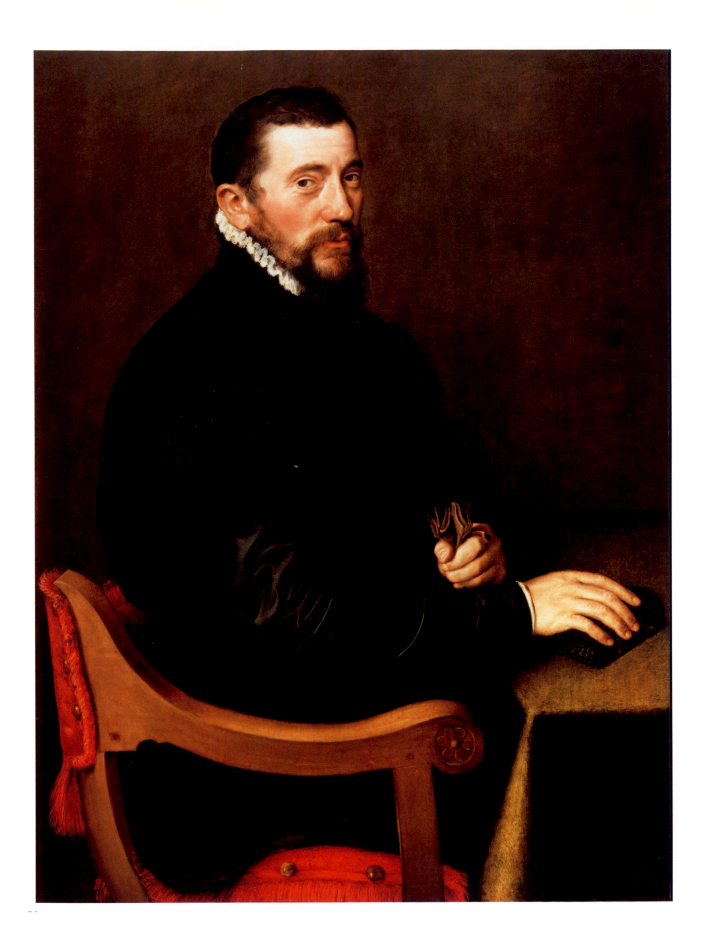

Anthonis Mor

(Utrecht about 1516-9–Antwerp 1575-6)

Portrait of a man aged 28

Oil on panel 117 x 82.5 cms

Painted in Netherlands in 1559

The sitter remains unknown but he is likely to have been a Netherlander owing to the date inscribed on the contemporary frame round the picture. In common with many other sitters at the time he holds a pair of gloves. On his index finger is a gold signet ring set with a precious stone which suggests that he was a man of some substance.

The details of Mor's career are unusually well documented for an artist of the time, owing to the fact that he had so many important patrons in several different countries. Mor was apprenticed to Jan van Scorel whose portrait he painted when Scorel was in old age (London, Society of Antiquaries). Mor was recorded as a master in the Guild at Antwerp in 1547, where he began to paint official portraits of the Spanish administration. He was then invited to Spain in order to paint portraits of the Royal Family. By 1553, Mor was in Brussels and in the following year he was back in Utrecht. He then set off for England, on the instructions of King Philip II of Spain, in order to paint Queen Mary Tudor (Madrid, Prado). On Philip's further instruction, Mor returned to Spain in 1559 but was back in the Netherlands around 1560 where he remained for the rest of his life, dividing his time between Utrecht, Brussels and Antwerp. Mor was the most skilled of all Netherlandish portraitists in the middle years of the 16th century, and his influence was widespread both in the Netherlands, Spain and England. Mor also painted religious subjects although Van Mander's extensive and adulatory biography only mentions the portraits.

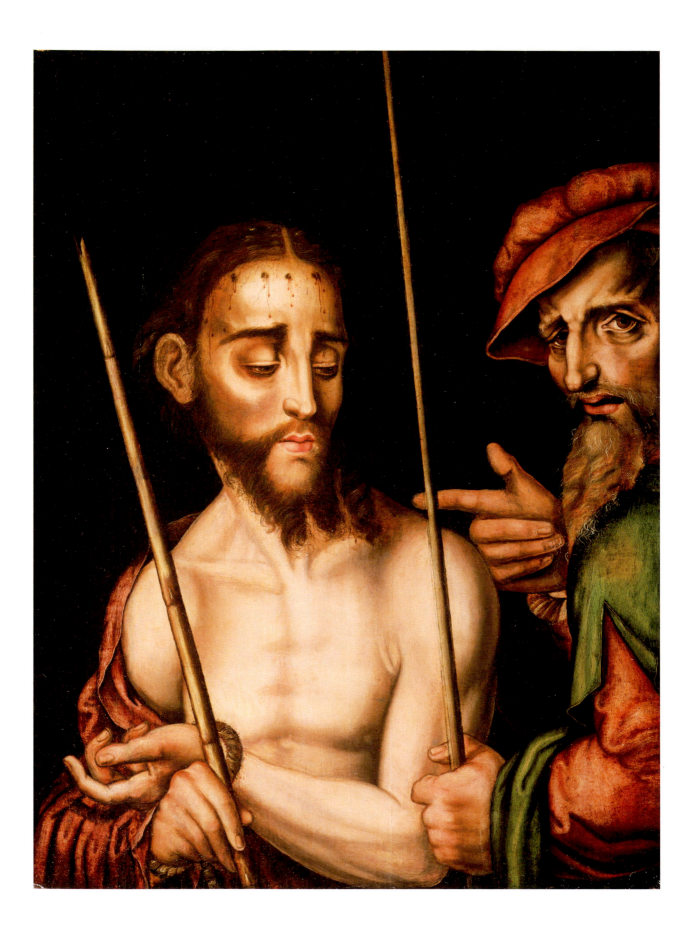

Luis de Morales (El Divino)

(Badajoz (Extremedura) about 1509–Badajoz 1586)

Ecce Homo

Oil on panel 76.5 x 57.5 cms

Painted in Badajoz early 1560s

The artist has given a very personal interpretation of the subject which is taken from the Gospel according to St John. The moment depicted is when Pilate announces to the assembled crowd, 'behold the man'. Christ's face shows the marks left by the Crown of Thorns on his forehead, and he holds a reed sceptre in mockery of his kingship. *Ecce Homo* was one of Morales' favourite themes and there are many variations known, each one with many small differences. The version in the Academia de San Fernando, in Madrid, with an extra figure added on the left, depicts an earlier moment in the narrative where Christ is still wearing the Crown of Thorns and the purple robe, also in mockery of his kingship. This one is stylistically independent of many of the others, except for the closely-related work in the church at Arroyo de la Luz (Extremadura), which can be dated through documentation to the years 1563–68. The latter forms part of a complex altarpiece, which has been in the church since it was painted.

It has been suggested that Morales' first teacher was Pieter van Kempenaer (see page 55), who was in Seville from 1537. However, the main formative influences on Morales came from Italian sources, in particular Leonardo da Vinci (1452–1519) and Sebastiano del Piombo (see page 73). There is no early authority for a supposed Flemish influence and all of the artist's early works in Badajoz betray some Flemish elements. The first certain record of Morales dates from as late as 1546. Most of the artist's recorded career was spent in Badajoz painting altarpieces in the area. Examples survive at or from Alcántara (1551), Arroyo de la Luz (1563–68), Higuera (1565) and Evora in Portugal (1568). Morales worked for three successive Bishops of Badajoz, Francesco de Navarra (1545–56), Don Cristóbal de Rojas y Sandoval (1556–62) and lastly from 1564 to 1569 for Juan de Ribera. The artist's range of compositions is limited and his subject of the Virgin and Child is repeated with many subtle variations throughout his career. He also favoured the *Ecce Homo* and the Pietà which gave him repeated opportunity to depict a suffering or a dead Christ with great spirituality, hence the soubriquet of El Divino. A detailed chronology of Morales' work cannot yet be worked out owing to the lack of dated or documented works in the later part of his career. The influence of Leonardo da Vinci and other Italian masters is much stronger in the pictures which repeat the subjects and compositions of the documented early work.

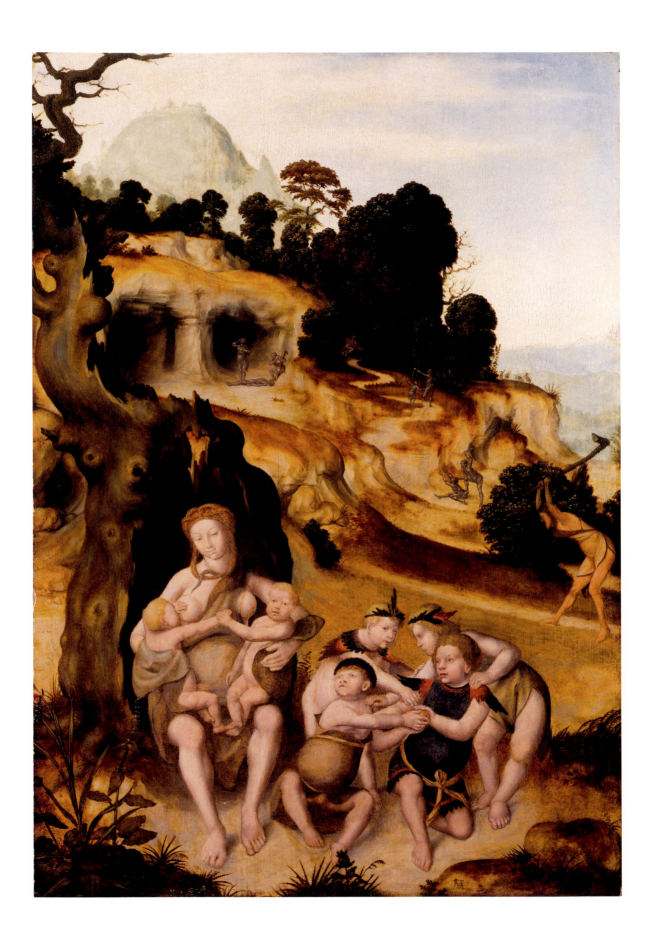

Jan Mostaert

(Haarlem about 1474–Haarlem about 1552–3)

The education of Cain and Abel
by Adam and Eve

Oil on panel 97.5 x 66 cms

Painted in Haarlem, uncertain date,

but perhaps about 1520–30

The picture's subject matter is complex but the main figures are Cain and Abel who are held in Eve's lap. The four other children symbolically hold the apple with which Eve was tempted. The background of the painting depicts various episodes from the story of Cain and Abel. The figure on the right is either Adam toiling or Abel tilling the ground. Immediately to the left and above are two figures, of which one is holding a bow and arrow, but these do not appear in the Bible story. The figure in the shadow of the bushes at the end of the winding path may well be Cain who took refuge in the Land of Nod, East of Eden after God's curse had been put upon him for killing Abel. The final scene, top centre, shows Adam and Eve mourning over the body of Abel.

The picture is attributed to Mostaert on stylistic grounds and on comparison with some of the landscape backgrounds in his portraits. The picture is likely to have been painted no earlier than 1520 as it betrays an awareness of developments brought back from Italy by Jan van Scorel and Maerten van Heemskerck.

There are usually thought to be no signed, dated or documented pictures by Jan Mostaert. However, Wimer interpreted the initials I.M. on the Virgin's bodice in a *Holy Family with the Infant St John The Baptist under an apple tree* (Rome, Museo del Palazzo Venezia) as that of Mostaert. (See Matthias Wimer, 'Eine Signatur

Jan Mostaerts', *Oud-Holland*, 1959, pages 246–7). Van Mander's account (1604) of the artist's life and works is sufficiently detailed to allow an idea of his range of subject matter, even if the evolution of his style remains conjectural. Friedländer's corpus (1973), while limited in number, is not entirely coherent. He included pictures such as the *Holy Kinship* (Amsterdam, Rijksmuseum) which were originally given to Geertgen tot Sint Jans (died Haarlem about 1495). There are a number of other pictures given to Mostaert which are also inspired by Geertgen in their miniature scale, intense lighting and eccentricity of expression. Mostaert developed in relative isolation in Haarlem but there was contact with Maerten van Heemskerck who, according to van Mander, greatly admired Mostaert. The rarity of work attributable to Mostaert can be explained by the fact that with a limited clientele in Haarlem it was unlikely that he had an extensive workshop. Moreover works were lost in the fire which destroyed his house, and it is also likely that there were losses during the Spanish siege of Haarlem in the 1570s. Mostaert's achievement as an artist is easily overshadowed by the more prolific and energetic of his contemporaries such as Jan van Scorel and Maerten van Heemskerck. Nevertheless, the best pictures attributed to Mostaert combine great meticulousness with freedom of spirit.

North Italian School 16th century

Portrait of a woman

Oil on panel 92 x 72 cms

There is still no clue as to the possible identity of the sitter although her high social status is clear, given her finger rings and knotted gold chain. The picture can be dated on grounds of distinctive costume which would suggest the 1560s. Various attributions have been put forward, none of them convincing.

Bartolomeo Passarotti

(Bologna 1529–Bologna 1592)

Portrait of a man with a letter

Oil on canvas 193 x 112 cms

Painted in Bologna, about 1570

The severe expression, austere dress and bold composition are all typical of the pictures painted in Northern Italy in the last quarter of the 16th century. The sitter has not been identified and he may have been a lawyer, as he is holding a paper. The picture can now be attributed to Passarroti whose work was remarkably similar to other artists working at the time especially Lavinia Fontana.

Although trained in Rome, Passarotti spent much of his career in Bologna. He painted altarpieces for several churches in the city, where they remain. He is now better known as a portraitist and most of them are painted in a sombre and dignified style.

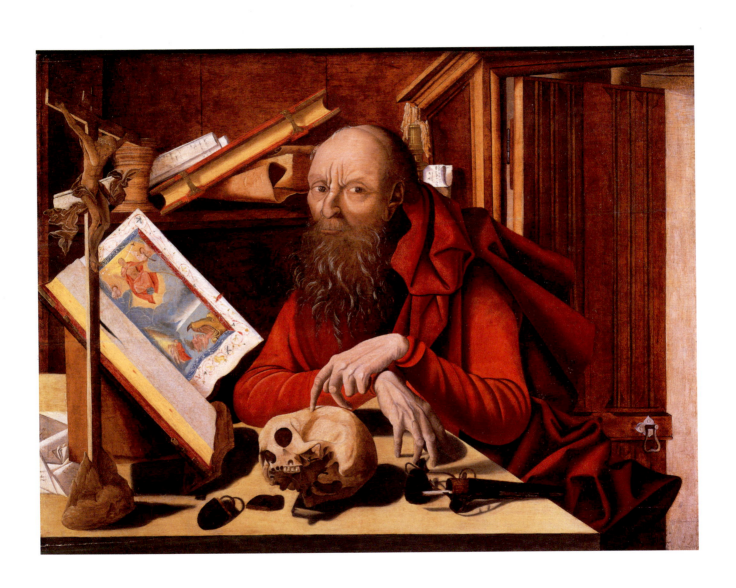

Marinus van Reymerswaele

and studio

(Reymerswaele working 1521–Reymerswaele 1547 or later)

Jerome in his study

Oil on panel 71 x 92.5 cms

Painted in the Netherlands, probably in Reymerswaele about 1520–about 1550

St Jerome (342–420) appears in numerous guises as one of the most popular saints in Western European art in the 16th and 17th centuries. He is shown in the *Wilderness of Chalcis learning Hebrew* by Ambrosius Benson, Pietro Faccini, and Palma Vecchio and as one of the four *Latin Doctors of the Church* by Claude Vignon. Here he is in his study contemplating death with a skull, an extinguished candle and an illuminated manuscript open at the page depicting The Last Judgement. As is the case with most of Reymerswaele's compositions there is an earlier source. In 1521 Albrecht Dürer (1471–1528) visited Antwerp, where he met Jan Gossaert, and painted his *St Jerome* (Lisbon, Museu Nacional de Arte Antiga), which was to be widely influential on a number of Netherlandish artists, including Reymerswaele.

This composition is one of several versions, each one with minor variations in the facial expression, furniture and details of the still life. There are, however, many levels of artistic quality between these versions, some of which may well be later than the artist's lifetime.

It is believed that Reymerswaele was born in the town of the same name, formerly on the island of South Beveland in the province of Zeeland, which was later engulfed by the sea. Signed and dated pictures by Reymerswaele extend over the years 1521–47. All of them are in some measure influenced by the Antwerp painter Quentin Metsys (1466–1530), and by Albrecht Dürer (1471–1528). The documentary evidence for Reymerswaele is sparse. The identification goes back to Van Mander who noted, 'Fame will hardly permit that one keeps silent about an art-full painter called Marijn van Romerswalen or Marijn de Seeu. There were many of his works in Zeeland. He had a rapid handling in the new manner, but more rough than smooth as far as I have seen. There is a tax gatherer sitting in his office with Wijntgls in Middelburg, well designed and handsomely executed. I do not know the dates of his birth or death – except that he lived at the time of Frans Floris.' (translation by Hessel Miedema). Marinus was the organiser of one of the most successful and prolific workshops of the whole Netherlandish 16th century, even though its precise location remains unknown. It could well have been at Reymerswaele itself, as the town was not finally abandoned to the sea until 1631. No fewer than 60 versions of *The Tax Gatherers* are known and all of them derive from a prototype by Quentin Metsys. The St Jeromes, however, are more original in their concept. As is the case with many Netherlandish workshops, judgement of the artist is made on more than one level. All but one of the handful of dated works by the artist are in Spain and they are of startlingly high quality. The numerous replicas and versions of the main compositions of the St Jerome have never been subject to collective critical scrutiny.

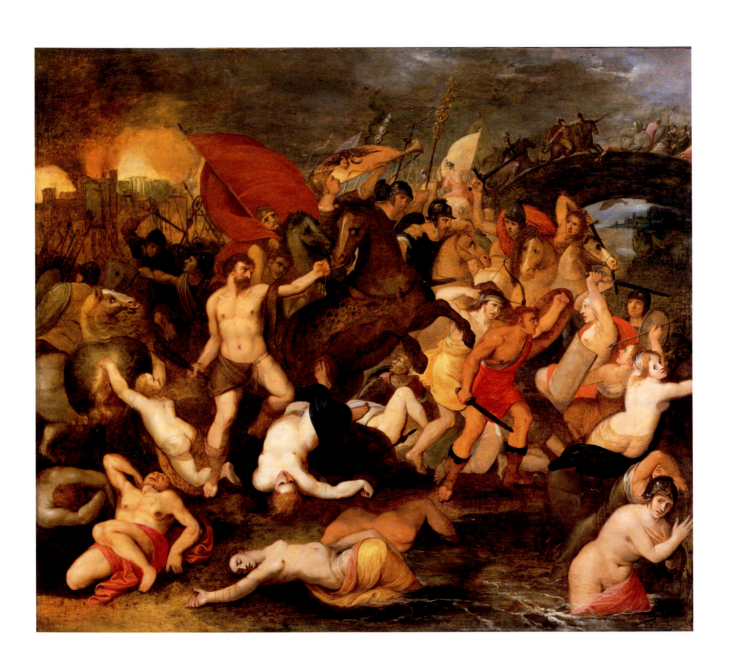

Peter Paul Rubens

(Siegen 1573–Antwerp 1640)

Battle of the Amazons

Oil on panel 149.8 x 131.3 cms

Painted in Antwerp 1590s

The subject, taken from early Greek history, was especially popular in the Renaissance and Baroque period. According to the legend the Amazons were war-like women who constantly invaded ancient Greece. Their military prowess was associated with bizarre customs which involved meeting with men of another race at certain seasons and killing or maiming any male offspring. The surviving females then had their right breast removed as it was thought it interfered with their fighting prowess. The Amazons were entirely mythical and many legends about them grew up in 5th century BC Greece. They were finally defeated by Theseus, and most of the paintings of the subject show the violent action where the women are overcome. The painting itself is now seen to be one of Rubens' very earliest works, whilst still under the influence of his master, Otto van Veen.

The artist was first recorded in Antwerp in 1589 and was first a pupil of Tobias Verhaecht (1561–1631). He next studied under Otto van Veen in the period 1596–97 and was also working under Adam van Noort in 1598. The artist spent the period 1600–08 in Italy painting in Venice, Mantua and Rome. He visited Spain in 1603–04 and then returned to Mantua. He was later in Rome and finally in Genoa before returning to Antwerp in 1608. Rubens also visited Paris in 1621–27, Madrid in 1628–29 and London in 1629–31. Rubens' main patrons were the Spanish regent in Brussels, Archduke Albrecht (died 1621) and later his widow, the Infanta Isabella Clara Eugenia (died 1633).

For the artist's early period there is still a great deal of uncertainty. Michael Jaffé's complete catalogue of Rubens' oil paintings of 1989 lists over 1,400 works by the artist. However, for the artist's early period up to the end of 1608, only some 80 pictures are listed and out of these a high proportion have to be attributed on stylistic grounds. Most of the securely documented works from this period were either painted for the Gonzaga Court at Mantua or for the churches of Rome and Genoa.

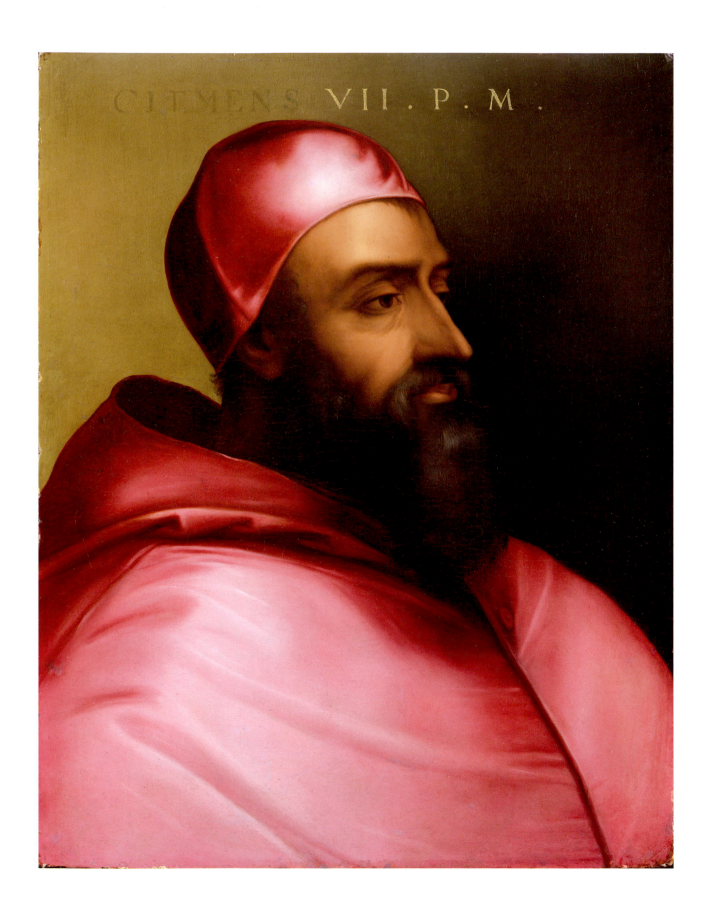

Sebastiano del Piombo

(Venice 1485–Rome 1547)

Portrait of Giuliano de'Medici (1478–1534) Pope Clement VII

Oil on panel 66 x 51 cms

Probably painted in Rome, about 1530

Clement VII's papacy (1523–34) was marked by political turmoil. He supported Francis I of France against the Emperor Charles V which resulted in the sack of Rome by the Emperor's troops in 1527. The occupying force imprisoned the Pope in the Castel Sant' Angelo in Rome, during which time he grew his distinctive beard. He also opposed the prospect of King Henry VIII of England's divorce from Catherine of Aragon, which was to precipitate the Reformation in England. In common with his Medici predecessor as pope, his cousin Giovanni de' Medici (Leo X 1513–21), he was an enlightened patron of the arts.

Sebastiano del Piombo is the most enigmatic figure of the High Renaissance. The reasons for this are not immediately clear as he enjoyed the patronage of three successive Popes, Leo X (1513-21), Adrian VI (1521–23) and Clement VII (1523–34). He was also a close associate of Michelangelo who provided preparatory drawings for Sebastiano's pictures, especially *The Raising of Lazarus* in the National Gallery, London, which was painted for Narbonne Cathedral where it remained until the early 18th century. Sebastiano's style ranges from a clear almost hard-edged Florentine manner familiar from Michelangelo's three surviving easel paintings, to a tenebrist style which owes more to North Italian painting such as Correggio. Much of Sebastiano's output was in fresco but he was also much in demand as a portraitist. Lack of a catalogue raisonné has meant that Sebastiano's portraiture has never been treated coherently even though a great deal is known about his patrons.

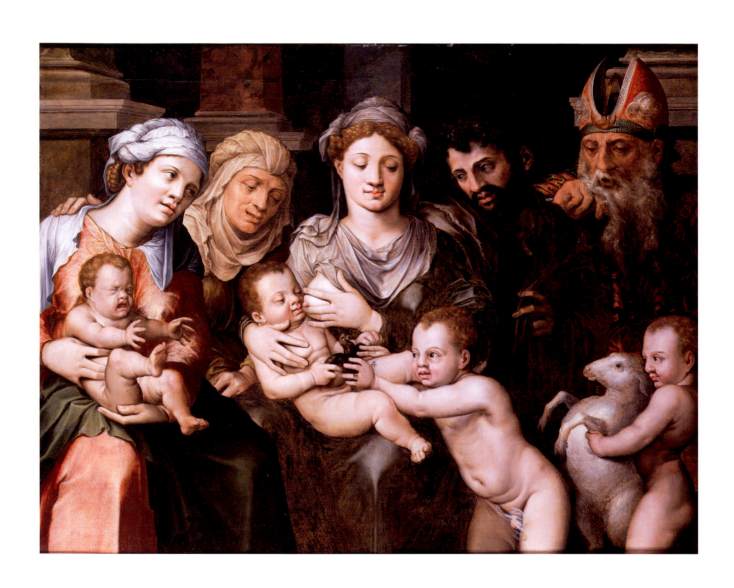

Vincent Sellaer

(about 1500–Mechelen before 1589)

The Holy Kinship

Oil on panel 106 x 136 cms
Painted in Mechelen mid-16th century

The theme of *The Holy Kinship* was a common one in late 15th and early 16th century Netherlandish painting, and was also used by Willem Key. The story usually consists of the families of the three marriages of St Anne, mother of the Virgin Mary. The story is from the golden legend, where St Anne married for the second time to Cleophas whose own daughter, Mary, was the mother of the Apostles, St James the Less, St Simon and St Jude. The third marriage was to Salome whose daughter, Mary, married Zebedee, and their children were St James the Greater and St John the Evangelist. It was the convention to depict Christ's generation as young children watched over by their mothers, the three Marys.

Only one signed work by Sellaer is known, a *Christ blessing the children* of 1538 in the Alte Pinakothek, Munich. A great deal of uncertainty still surrounds Sellaer's career as Van Mander, the main early source, grouped all the artists from Mechelen together, rather than giving them detailed biographies. Van Mander described a certain Vincent Geldersman, who has often been thought to be Sellaer, although this is still disputed. Reconstructing Sellaer's work on stylistic grounds has resulted in a coherent group of pictures, with their distinctive half-length figures, mannerist poses and limited subject matter. Almost all Sellaer's output in Mechelen was lost in the iconoclastic crisis of the 1560s. A further work documented as by Sellaer was donated to the Mechelen Guild in 1589. This panel is no longer traceable. In the current state of knowledge the chronology of Sellaer's work cannot be formulated, as his style remained consistent.

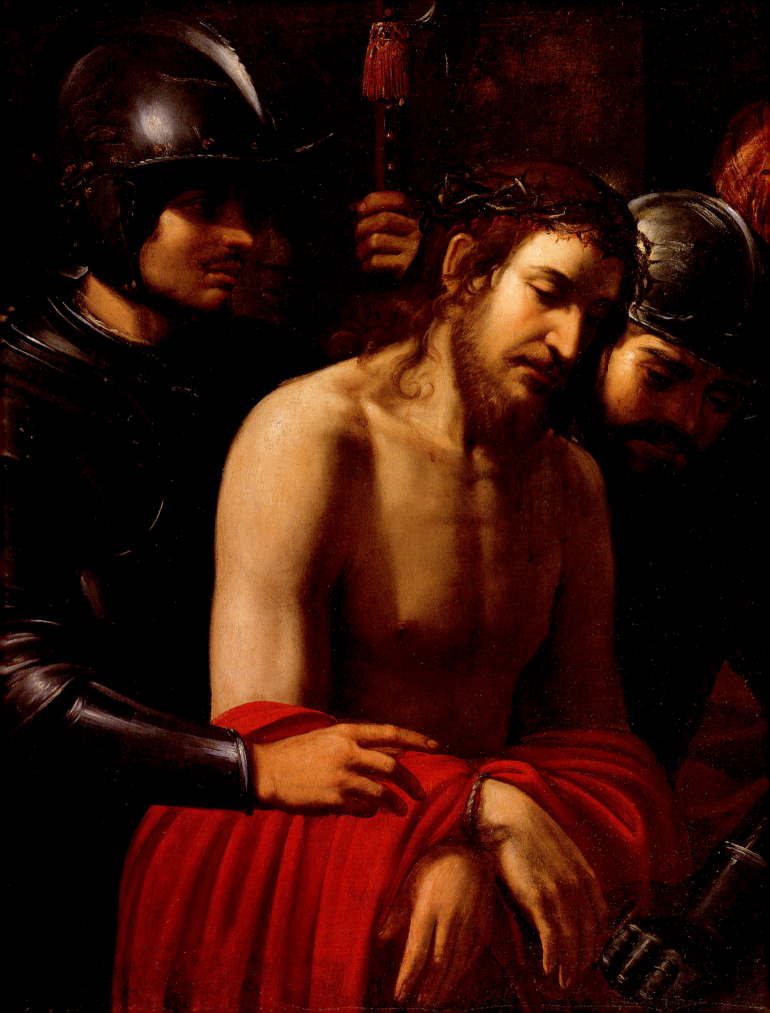

17ᵀᴴ CENTURY

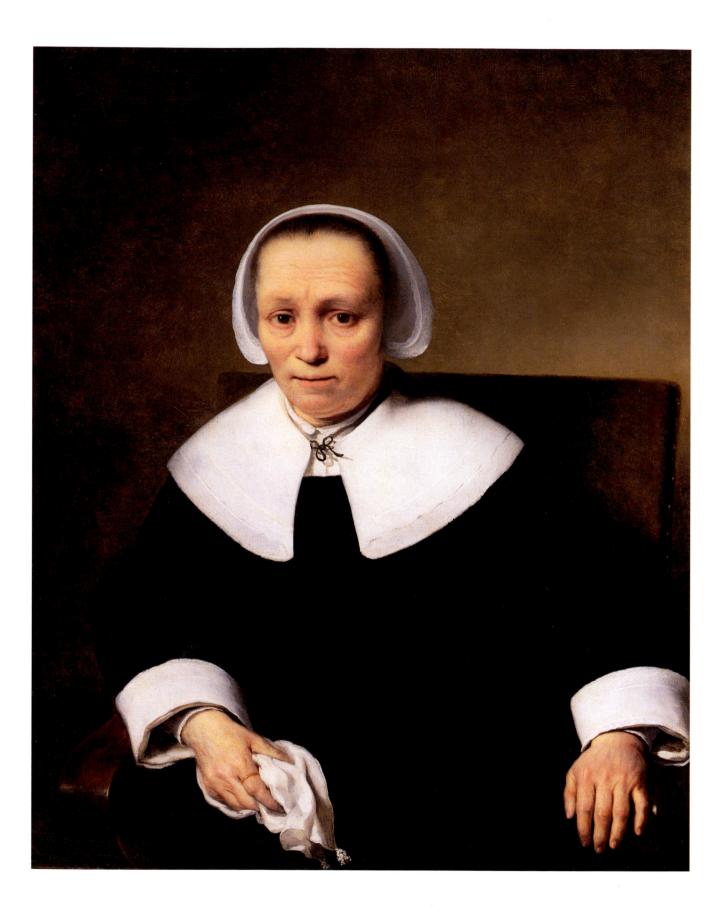

Ferdinand Bol

(Dordrecht 1616–Amsterdam 1680)

Portrait of a lady

Oil on canvas 88.6 x 72.6 cms

Painted in Amsterdam in 1653

In the 1640s and 1650s Bol began to specialise in painting middle class portraits, effectively taking over Rembrandt's successful types from the 1630s. There were various categories which were dependent on the treatment of the collar and ruff lace, or, as here, linen. The sitter herself has not been identified but this is the case with many other female portraits by Bol. In this example the influence of Rembrandt is strongly felt in the intensity of the expression and the careful balance of black, white and flesh tones. At the time of the picture's exhibition in London in 1999, it was noted that the handkerchief that the woman is wearing could be interpreted as a sign of prosperity and a symbol of chastity.

Bol's early years in Dordrecht are documented, but it is not known to whom he was apprenticed. It is usually thought that the artist arrived in Amsterdam in the mid-1630s when he entered Rembrandt's studio. The first documentary evidence for this comes as late as 1640 but no signed and dated work by Bol exists before 1642. Bol's subject pictures of the 1640s are close in style and composition to those of Rembrandt of the same period, but the two artists are no longer compared as equals as was the case until relatively recent times. Bol's later work became cooler and less Rembrandtesque, reflecting his success in Amsterdam as a portraitist.

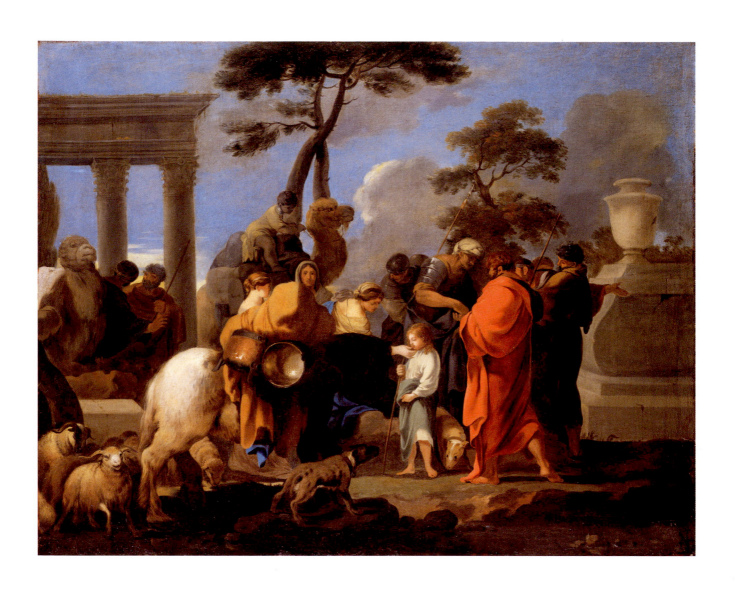

Sébastien Bourdon

(Montpellier 1616–Paris 1671)

Joseph sold by his brethren

Oil on canvas 88.9 x 116 cms

Painted in Paris later 1630s

The subject is taken from the Book of Genesis, where Joseph's jealous brothers tried to abandon him in a pit in the desert. They then decided to sell him when 'a company of Ishmaelites came from Gilhead with their camels bearing spices and balm and myrrh, going to carry it down to Egypt'. The painting shows the moment of financial transaction with the Ishmaelites. It was typical of Bourdon to pay attention to precise details such as the presence of the camels, and this sense of accuracy in the story could easily have been derived from Nicolas Poussin (1593–1665) whom Bourdon imitated. The picture is a good example of the artist's early Parisian period when he had achieved some originality. Typical of the artist in this period is the smoky blue tonality combined with strongly painted figures which recall the artist's earlier Roman work.

Bourdon's career took place in three main centres. His early work, which consisted mostly of genre pieces, was done in Rome where he was strongly influenced by Dutch masters working there. His pictures are also sometimes reminiscent of the French artist Jean Tassel. It was in Rome that Bourdon saw the work of Nicolas Poussin (1593–1665) and this influence was to remain with him throughout his life. Bourdon left Rome about 1637 and went to Paris where he was immediately successful, becoming one of the twelve original founding members of the Académie in 1648. He was then asked by the redoubtable Queen Christina of Sweden to become court painter in Stockholm in 1652. On the Queen's self-imposed exile to Rome in 1654, Bourdon returned to Paris where he spent the rest of his career. In spite of the shortness of his sojourn as court painter, his portraits of Queen Christina (Stockholm Nationalmuseum) remain his best known works. Bourdon is one of the most varied of all French 17th century painters as he encompassed almost all the genres practised at the time. Most of the artist's major religious pictures are heavily indebted to Poussin and the landscapes to Gaspard Dughet (see page 97).

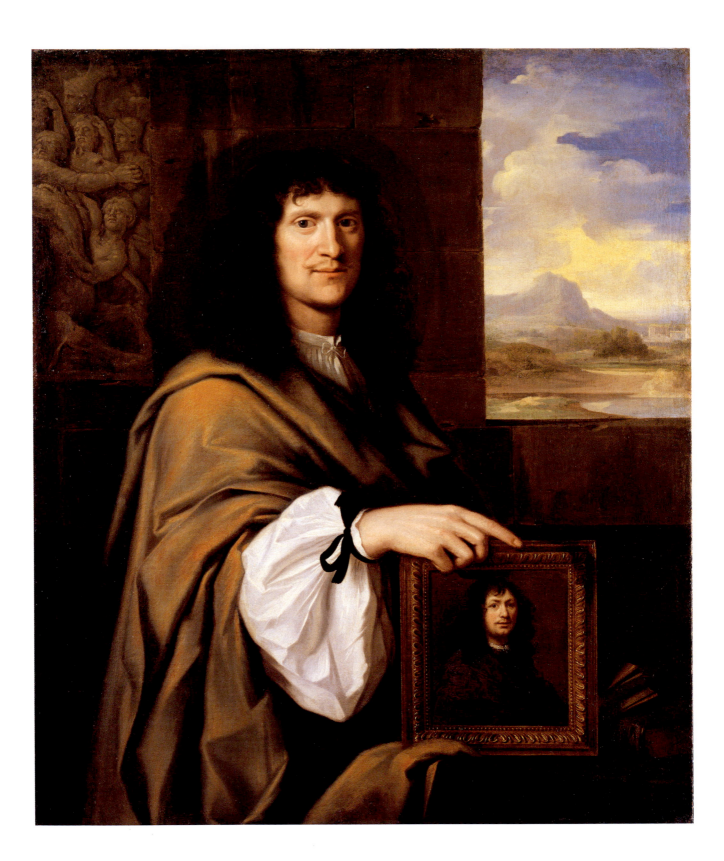

Sébastien Bourdon

(Montpellier 1616–Paris 1671)

A man holding a portrait

Oil on canvas 107.3 x 91.5 cms

Painted in Paris, probably 1660s

The portrait within a portrait is found quite often in the context of French 17th century painting. The treatment of the figure, especially the sleeves, is reminiscent of the artist's most famous portrait, the *Homme aux rubans noirs* in the Musée Fabre, Montpellier, which is usually dated in the late 1650s. The portrait held by the sitter seems to be of a slightly earlier generation. The sitter is shown in costume which suggests a date in the 1660s, and Bourdon's familiar hand can be seen in the background landscape.

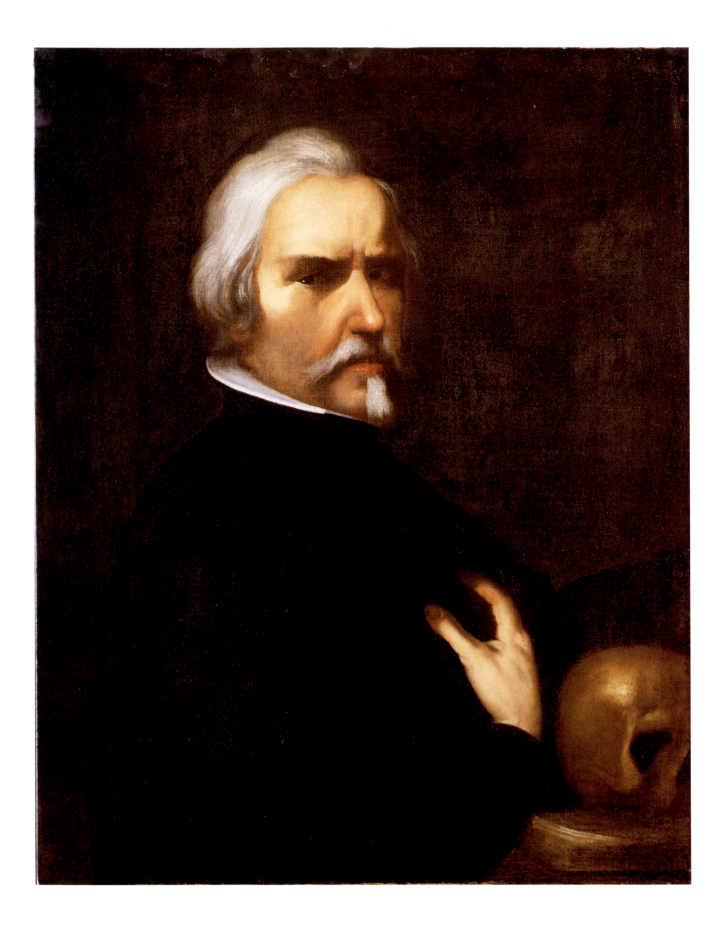

Vicente Carducho

(Florence 1576-78–Madrid 1638)

Portrait of a man with a skull and a book

Oil on canvas 83 x 63 cms

Painted in Madrid, early 1630s

This unknown man is distinctive enough with his carefully trimmed moustache and beard. The skull and book could denote a variety of professions but it is unlikely to be a self-portrait, as was wrongly thought in the 19th century. The old attribution to Alonso Cano (1601–67) has had to be abandoned as there are no closely comparable portraits in his work. The painting formed part of two of the most important 19th century collections of Spanish painting outside Spain; firstly that of King Louis Philippe of France in the Louvre and later in exile at Claremont, Surrey, and secondly the Stirling Maxwell Collection in Scotland.

Carducho was taken to Spain at an early age by his older brother, Bartolomé (about 1560–1608) and brought up in the Spanish artistic tradition. Carducho was the leading painter in Madrid before the arrival of Velasquez in 1627, having worked for both King Phillip III and the young Phillip IV. Most of Carducho's output was of religious subject matter for the churches and convents of Madrid where many still remain. Unsurprisingly, there are many reminiscences in Carducho's style of Italian late 16th century painting. Many of the artist's earlier works were executed for collections and churches in Valladolid; his major work there was an extended cycle of 56 pictures for the church of S. Diego, which included 27 scenes from the life of Saint Bruno. At the end of his life in 1633, Carducho published an influential *Dialogue on Painting* which was the most important theoretical work of the Spanish 17th century.

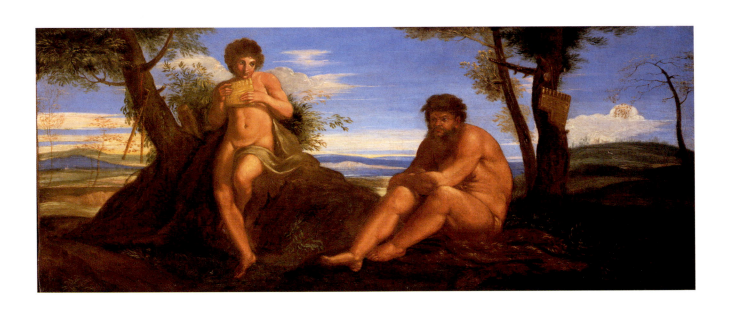

Antonio Carracci

(Venice 1589–Rome 1618)

Bacchus and Silenus

Oil on canvas 34 x 83.5 cms

Painted in Bologna, about 1610

The composition by Annibale Carracci in the National Gallery, London, from which this picture is derived, is usually thought to be the panel of a keyboard instrument, owing to its distinctive irregular shape. Here the painting is on canvas, which suggests that it did not form part of a musical instrument.

Bacchus is well known as the god of wine and is often shown with Silenus who was in his retinue. Silenus is usually shown drunk, albeit affectionately and with respect, owing to the belief that he had the gift of prophecy.

The artist was the illegitimate son of Agostino Carracci (1557–1602) and nephew of Annibale Carracci, whose style he imitated. After Agostino Carracci's death, Antonio went to Rome where he entered the studio of Annibale (died 1610). Very few paintings can be attributed to Antonio with certainty. He is recorded as the assistant of Guido Reni in the painting of two lunettes in the Capella Paolina in the Palazzo Quirinale, Rome – *The Presentation in the Temple* and the *Annunciation of the Angel to Joachim*. The artist's easel paintings are never securely documented and the pictures attributed to him in Salerno's 1956 article vary greatly in style.

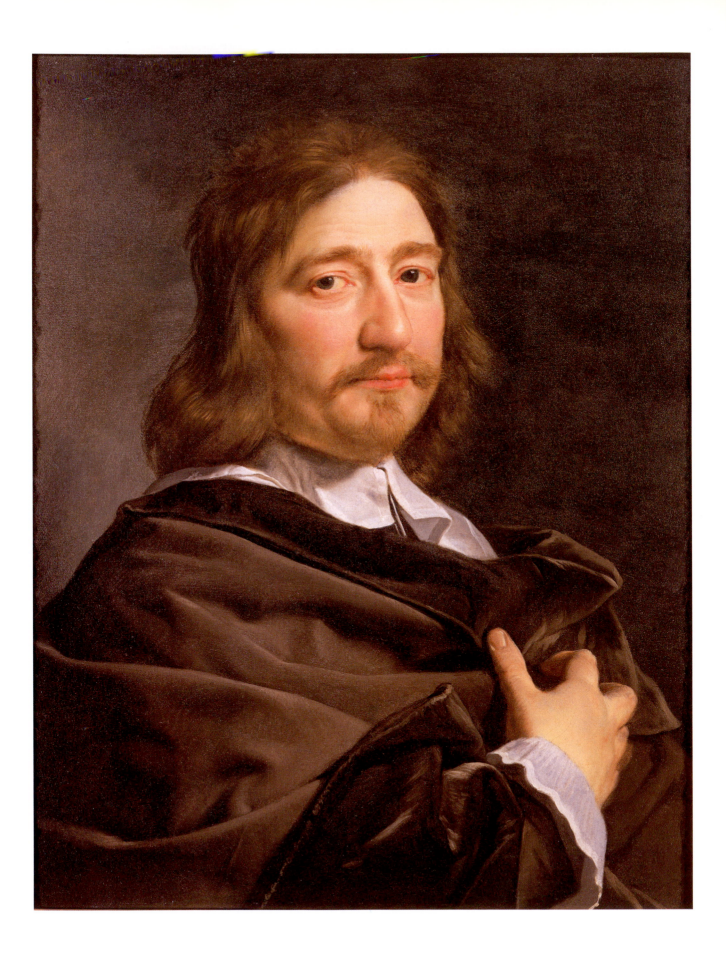

Philippe de Champaigne

(Brussels 1602–Paris 1674)

Self-portrait

Oil on canvas 62 x 50.8 cms

Painted in Paris 1640s

This striking portrait is of the artist himself. The identification is based on his much older appearance in a painting executed in 1668 and known only through copies and an engraving of 1676. On stylistic grounds, the picture can be placed in the 1640s, based on comparison with many surviving single male portraits from this period. The artist also painted his wife at approximately the same time as himself, in a work recently identified in the Bowes Museum at Barnard Castle on the basis of a signed drawing.

Most of Champaigne's long career was spent in Paris but his origins and training were in Brussels. This meant that he never lost the power to paint highly charged Baroque altarpieces even though in his later years they became tempered with the influence of French classicism.

Many of the artist's later works show a deep spirituality. This is almost certainly because his daughter, a nun in the Jansenist Monastery of Port-Royal outside Paris, underwent a miraculous cure for an illness. This inspired Champaigne to paint the Ex-Voto in the Louvre, Paris.

True to the Flemish tradition, Champaigne was also an extraordinarily accomplished portrait painter, both of king and court, as well as the bourgeoisie. Champaigne arrived in Paris in 1621 at the age of nineteen and spent the rest of his career there. He was particularly successful at the Court of Louis XIII (died 1643), painting the King and his chief minister Cardinal Richelieu (died 1642) of which there are versions in the National Gallery, London, Hampton Court, Warsaw and elsewhere. The artist also painted a series of major altarpieces for Paris churches (two in the Wallace Collection, London). In his later years his output declined and the pictures became more modest in scale.

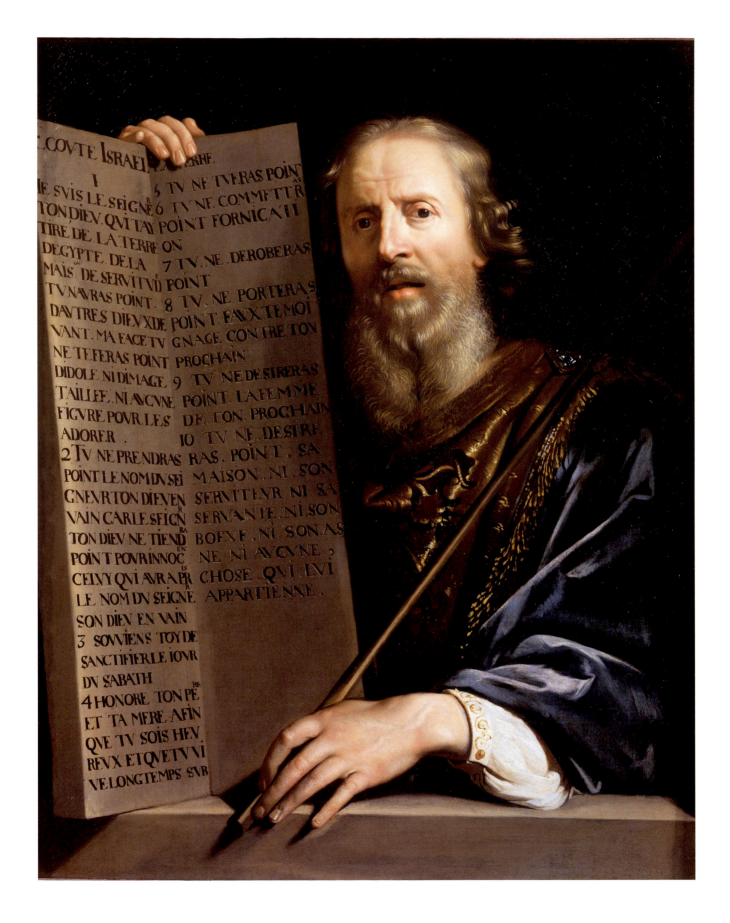

Philippe de Champaigne

(Brussels 1602–Paris 1674)

Moses and the Tablets of the Law

Oil on canvas 92 x 72 .2 cms

Painted in Paris 1640s

In the 18th and 19th centuries this was one of Champaigne's best known images because of engravings and the fact that two of the three versions were in prestigious collections. The version in the Hermitage at St Petersburg since 1808 was previously in the Paris collection of the duc de Choiseul-Praslin, while the Schorr version was in the enormous collection of Napoleon's uncle, Cardinal Fesch, in Rome. This picture was later in the collection of the well-known Paris surgeon, Le Roy d'Etiolles. Neither of these pictures corresponded to the engraving published in 1699. The engraved composition reappeared in the early 20th century and is now in the Milwaukee Art Center. The subject is taken from Exodus, where God gives Moses the Ten Commandments, 'And the Lord said unto Moses, come up to me into the mount, and be there; and I will give thee tables of stone, and a law, and commandments which I have written; that thou mayest teach them'. The subject is also referred to again in Deuteronomy, 'At that time the Lord said unto me, Hew thee two tables of stone liken to the first, and come up unto me into the mount. And I will write on the tables the words that were in the first tables…' It is likely that the artist is using the second Biblical quotation as there are clearly two tables of stone in the picture. Champaigne favoured the old man used as a model in this picture as he appears in a very similar pose in the artist's *St Paul* in the Musée des Beaux-Arts at Troyes. The same model was also employed in the *Presentation in the Temple* painted for the church of Saint Honoré in Paris in 1642, and now in the Musées Royaux des Beaux-Arts at Brussels.

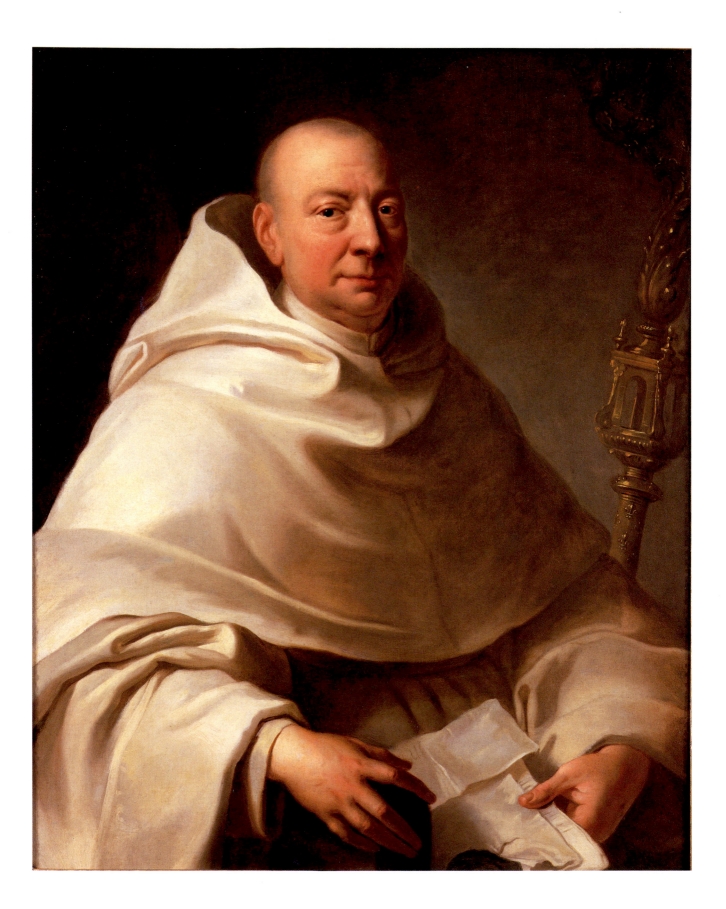

François de Troy

(Toulouse 1645–Paris 1730)

Portrait of Père Jean de Gravier, supérieur des Feuillants

Oil on canvas 92 x 74.5 cms

Painted in Paris, about 1700

The artist's eldest son, Jean-Antoine de Troy (born 1669), entered the Order of the Feuillants and it is likely that this portrait represents the head of the Order with Jean-Antoine entered as a young man. Jean Antoine left for Florence in 1696 taking with him François de Troy's *Self-portrait* for the collection of the Grand Duke of Tuscany, where it remains in the self-portrait collection in the Uffizi, Florence. The Feuillants wore a distinctive white robe with a hood, which is related to that favoured by the Cistercians. The Feuillants had been founded in 1577 at Feuillant near Toulouse, and were an offshoot of the Cistercian rule. The artist was also painter-in-ordinary to the Feuillants and exhibited a portrait of the member of the Order in the Salon of 1704.

François de Troy left his native Toulouse at an early age and became the pupil in Paris of Nicolas Loir and Claude Lefebvre. He was received into the Académie in 1674, which was very young by the standards of the time, and gradually rose in status until he became its director in 1708. He was also the master of Johann Clostermann. At about this time he produced a commemorative group portrait of himself, his wife, and his six children (Versailles, Château, deposited at Le Mans, Musée de Tessé). One of the artist's sons was the much better known Jean-François de Troy whose genre paintings epitomise early 18th century French taste. François de Troy himself has been overshadowed as a portraitist by his illustrious contemporaries especially Hyacinthe Rigaud and Nicolas de Largillière.

Nevertheless, François de Troy's portraits show great merit by the fact that they are more severe and introspective than those of many of his contemporaries. Amongst his most celebrated were two of the King's mistresses, Mme de Montespan and Mme de Maintenon. He never assimilated the 'Parisian chic' which was to dominate so much of French 18th century portraiture.

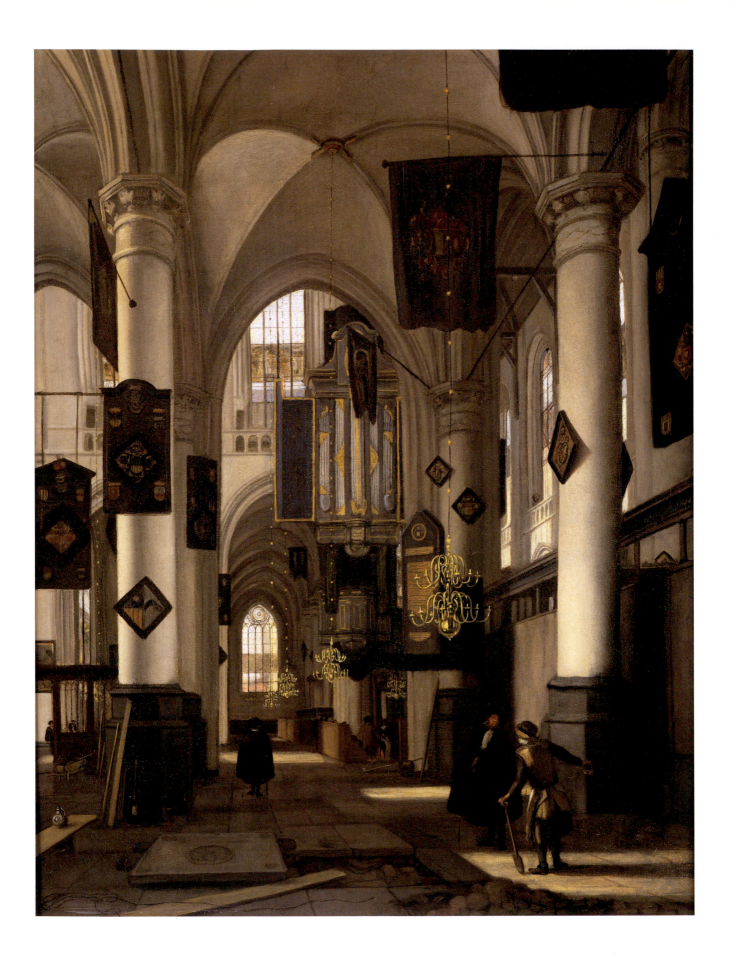

Emanuel de Witte

(Alkmaar 1617–Amsterdam 1692)

Interior of a Protestant Gothic Church

Oil on canvas 80 x 62 cms

Painted in Amsterdam 1680s

This church interior is entirely idealised and unrelated to any surviving building in the Netherlands. The artist's love of light and shadow is very prominent and this reinforces the three dimensional effect of the architecture. The painting was formerly thought to carry the date 1684, although this is no longer visible. The picture is likely to be a late work by the artist, on grounds of style. The detail in the painting is illustrative of the changes which the Protestant users of the originally Catholic medieval churches brought about. Here, unusually, the stained glass survives in the upper windows, and it is in a Renaissance style, very close to the unique survival of such complete work in the Northern Netherlands at Gouda. The pillars are adorned with numerous lozenge-shaped painted coats of arms or hatchments, which were temporary adornments hung up after those bearing the arms had died. The gothic arches have been blocked with heavy panelled screenwork, and numerous flags, mainly of military origin, hang from the iron tie beams used to support the tall thin columns, so necessary in the unstable Dutch soil. The scene also shows a grave being prepared. The ornamental grave slab has been removed and the grave-digger is in conversation with a well-dressed man.

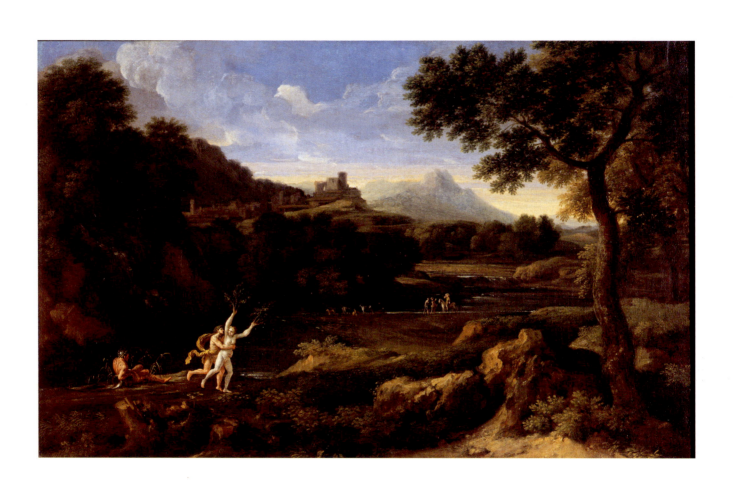

Gaspard Dughet

(Rome 1615–Rome 1675)

Wooded landscape with Apollo and Daphne

Oil on canvas 42 x 65.8 cms

Painted in Rome 1650s

The subject from Ovid's *Metamorphoses*, which involved Daphne's transformation into a tree as a result of her being pursued by Apollo, was much favoured by landscape painters. In this instance, it is likely that the figures were added by another hand as they are so conspicuous. When Dughet added his own figures to his pictures they were usually much more discreet. In this instance, the figures are traditionally attributed to Filippo Lauri (1623–94).

Dughet's long career was spent entirely in Rome, much of it in close association with Nicolas Poussin who became his brother-in-law in 1630. At the same time, the young Dughet became Poussin's apprentice and was trained, it appears, entirely as a landscape specialist. Poussin's own interest in landscape as a separate genre did not fully develop until the 1640s, and Dughet must, therefore, be credited with a significant role in the development of classical landscape. He also painted a number of ambitious fresco cycles in Rome, which are more romantic and decorative in character. A documented example of this, which is very rare in Dughet's long career, was that in February 1657 he received 30 scudi for two landscapes he executed in the background of Filippo Lauri's (1623–94) *Sacrifice of Cain and Abel* and Lazzaro Baldi's *Creation of Adam and Eve*, in the Palazzo Quirinale, Rome. The other documented fresco cycles of landscapes by Dughet are in the church of S. Martino ai Monti, Rome, and the Palazzo Colonna, Rome. As a painter of small landscapes, he was prolific. Dughet's pictures are very difficult to date even though the general style development can be worked out. His early works are more descriptive while his mature works are more classical and seem to have been influenced by Poussin. Towards the end of his career a greater sense of atmosphere creeps in, and this may be the influence of the later work of Claude Lorrain.

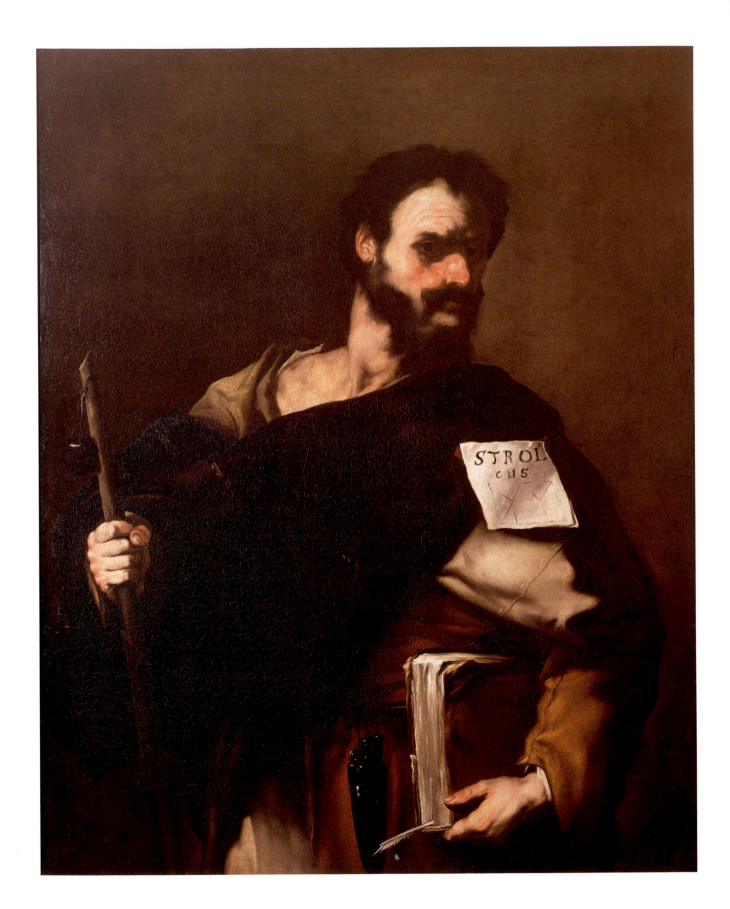

Luca Giordano

(Naples 1634–Naples 1705)

The Philosopher Astrologus

Oil on canvas 128 x 99 cms

Painted in Naples late 1650s

Philosophers were amongst Giordano's favourite subjects in the early part of his career when he was strongly influenced by Ribera (see page 115). In its dense shadows and sharp lights, the picture is strongly Caravaggesque, even though the influence has come via Ribera. The subject is a rare one, as artists preferred astronomers rather than astrologers who were frowned on by Christian authorities. The curious symbols on the parchment have been interpreted as a chart for a horoscope. Philosophers in general were traditionally depicted as poor, probably because their profession was not expected to financially gain. The astrologer, however, is depicted in the guise of a beggar, which is the only status a Christian society would have accorded him at the time. The bearded model is familiar from many other early works by Giordano.

Known in his lifetime as 'Fa presto', Giordano was the Italian equivalent of Rubens in his prodigious energy and variety of accomplishment. His early work was strongly under the influence of Ribera and most of these pictures were single figures of philosophers and saints. Giordano rapidly developed a distinctive style of his own, including a wide variety of influences, which ranged from the Venetian Renaissance to Caravaggio (1571–1610) himself. Giordano often repeated the same composition, in different formats, throughout his long career. After Naples, he worked successively in Rome, Florence and Venice. At the end of his career, he spent an equally prolific period in Spain between 1690 and 1702.

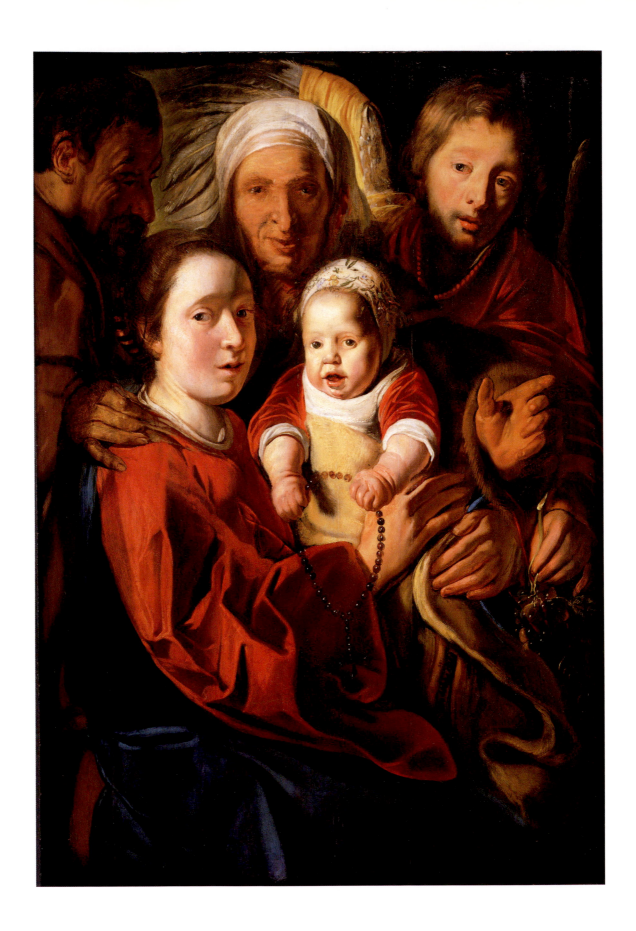

Jacob Jordaens

(Antwerp 1593–Antwerp 1678)

Holy Family with St. Anne and an Angel

Oil on panel 107 x 74 cms

Painted in Antwerp mid 1620s

The Holy Family represents one of Jordaens' favourite themes painted over the decade leading up to about 1630, often with an unusual degree of intimacy. The model for the child is usually considered to be one of the artist's sons, in this instance born about 1625 which would date the picture a year or two later. There is a strong contrast between the elaborate symbolism of the picture, with the Christ Child holding the rosary and the angel bringing the grapes, and the powerful realism of all the models. The forcefulness of the picture shows the strong influence of Rubens.

Jordaens spent his entire career in Antwerp and was continuously successful there, receiving major commissions from most of the city's leading art patrons.

Rubens (see page 71 and pages 121–3) and Van Dyck died in 1640 and 1641 respectively, and Jordaens became, by default, the leading Flemish painter to whom foreign patrons were attracted. This included Queen Christina of Sweden and Amalia von Solms for the decoration of the Huis ten Bosch at The Hague. Jordaens' style was formed under Rubens rather than Van Dyck, but emboldened Rubens' subtleties. Jordaens' flaccid flesh, seen in old men or the effects of over-indulgence seen in middle-age, are often startlingly realistic. The comprehensive exhibition of his work held in Antwerp in 1993 demonstrated Jordaens' great energy, even outside his enormous output as a painter. He was a fluent draughtsman and produced numerous and accomplished tapestry designs.

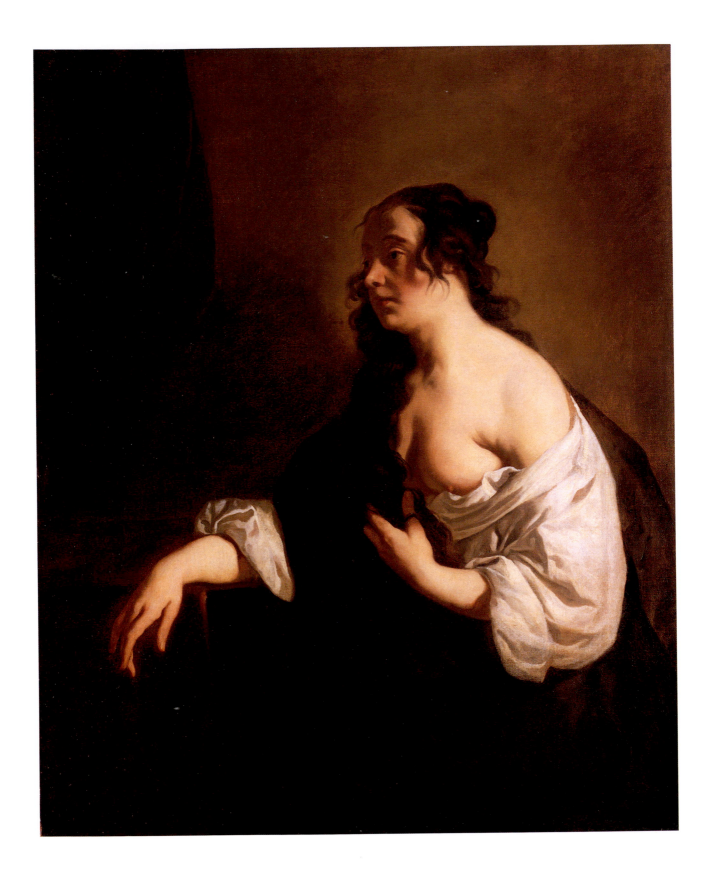

Sir Peter Lely

(Soest, Westphalia 1618–London 1680)

Portrait of a lady

Oil on canvas 105.5 x 91.2 cms

Painted in London 1650s

In his early years, Lely used the model who appears in this picture in a variety of guises. She is included in *Europa and the Bull* (Devonshire Collection Trustees, Chatsworth, Derbyshire), *The Nymphs and Satyrs* (Dulwich Picture Gallery), *Susanna and the Elders* (Burghley House, Exeter Trustees and Birmingham City Art Gallery) and the *Cimon and Iphigenia* (Knole, Kent, Lord Sackville). The picture is not strictly a portrait as the model is shown *en deshabille* and without any of the attributes which would indicate her possible social status. Lely's continental background means that the picture could be interpreted as a 'fancy piece' and there is neither specific subject matter nor identifiable sitter.

In a century dominated by foreign artists working in England, Lely was second only to Van Dyck as a portraitist of the English aristocracy and Court. The artist's early style was quite different, as he was received into the guild at Haarlem in 1637 as a pupil of Pieter de Grebber. It was from this Haarlem classicist that Lely developed a distinctive style of painting female nudes in landscape settings. Few of these survive, examples being at Chatsworth in the collection of the Devonshire Trust and in the Dulwich Picture Gallery, although they are of great distinction.

Lely arrived in England in about 1643 at which time the Civil War was in progress. Lely seemed to have been used by both sides as a portraitist, which included the imprisoned Royal Family and the celebrated *Portrait of Oliver Cromwell* (Birmingham, City Gallery). After the restoration of the monarchy in 1660, Lely developed a Court style memorably described by Waterhouse: 'He caught to perfection not only the rather raffish tone of Charles II's female associates but the serious qualities of the Admirals in the Anglo-Dutch Wars'. Lely also amassed one of the most distinguished collections of Old Master Drawings assembled at the time.

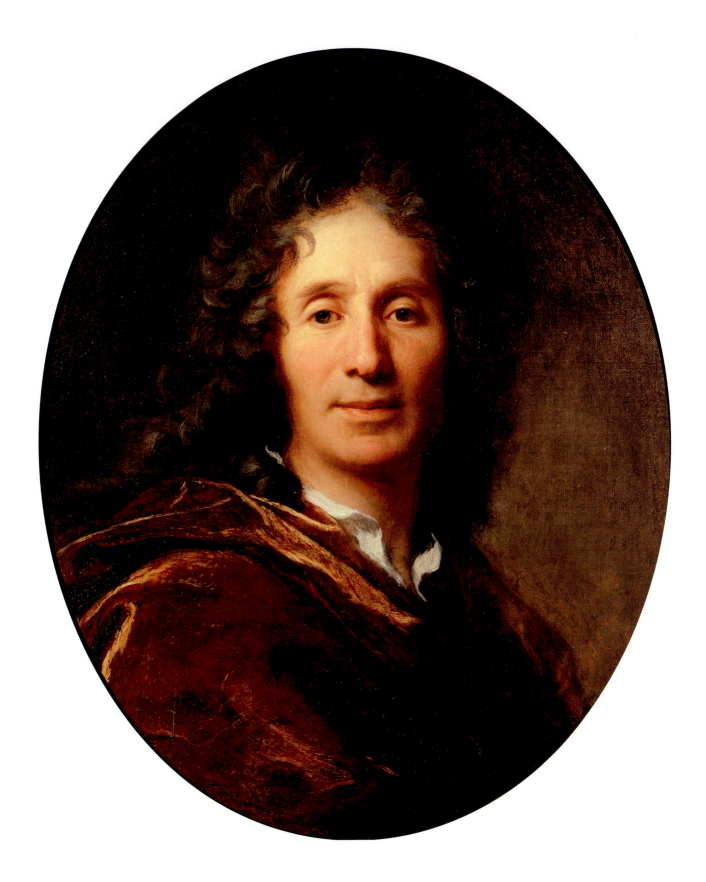

Pierre Mignard

(Troyes 1612–Paris 1695)

Self-portrait

Oil on canvas 62 x 52 cms
Painted in Paris 1660s

It is likely that this middle-aged man is a self-portrait of the artist as his likeness appears in several other works, although they are mostly rather later.

Mignard was apprenticed at the age of twelve to Jean Boucher (about 1575–1632) at Bourges, but this lasted only a year. After returning to Troyes, Mignard entered the studio of Simon Vouet (see pages 131–3) in Paris. In 1636, the artist left for Italy, where he was to remain for twenty years. During this long period, Mignard divided his efforts between subject pictures and portraiture. He received numerous portrait commissions from two popes, Urban VIII (died 1644) and Innocent X (died 1655), as well as the many leading Roman families. Relatively few of these portraits are identifiable today. In 1654 the artist visited Bologna, Modena, Parma and later Venice. He returned to Rome in 1655 and two years later arrived in Paris, where he was to remain for the rest of his long career.

After the assumption of personal power by Louis XIV in 1661, Mignard became the unofficial portraitist to the court. He also executed the decoration of the dome of the Paris Church of the Val-de-Grace, a commission by the King's consort (1662–63), Anne of Austria. Mignard also created decorative schemes for the Royal Palaces at Saint-Cloud and Versailles. It was, however, only on the death of Charles Le Brun (1619–90) in 1692, that Mignard received any official honours, as they all had been taken up by Le Brun. The artist was named 'Premier peintre du roi', and Director of the Royal Manufactures. At a single session of the Académie, the 79 year old artist was named *académicien*, *professeur*, *recteur*, *directeur* and *chancelier*. In contrast to Le Brun, whose style was ambitious and full of grandeur, Mignard's art was essentially courtly. Many of the pictures currently attributed to him are done so on grounds of style as there are so few signed or documented works.

Pierre Mignard

(Troyes 1612–Paris 1695)

Portrait of John II, Casimir (1609–72), King of Poland (1648–68)

Oil on canvas 91.2 x 73.5 cms

Painted in Paris, probably in 1672

The reign of John II Casimir, the last elected Vasa King of Poland, was unusually turbulent, even for Poland. There was a catastrophic war with Russia (1651–54) and a final humiliation when Poland was forced to cede the whole of the Ukraine and Smolensk to Russia at the truce of Andrussov in 1667. After his abdication in 1668, the King passed his exile in Paris, where he married Françoise Mignot in the last year of his life.

Pierre Mignard

(Troyes 1612–Paris 1695)

Portrait of Claudine Françoise Mignot, (1624–1711)
wife of John II Casimir, ex-King of Poland

Oil on canvas 91.8 x 73.5 cms

Painted in Paris, probably 1672

The sitter was the widow of the Nicolas de L'Hopital, maréchal de Vitry. She married the ex-King in 1672, the year of his death. Her connection with Mignard had been established many years earlier when her first husband had commissioned a series of decorations for the chapel of the Château de Courbert-en-Brie. These decorations do not survive.

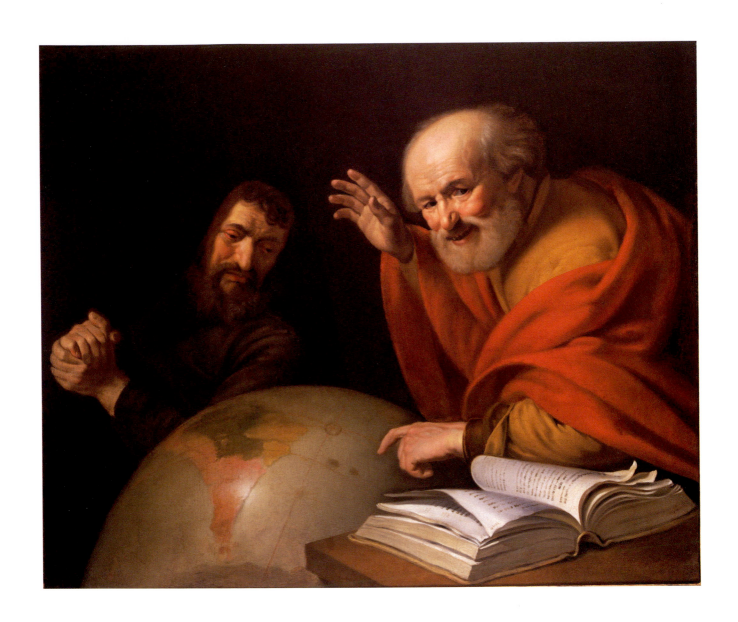

Johan Moreelse

(Utrecht about 1603–Utrecht 1634)

Democritus and Heraclitus

Oil on canvas 86.4 x 103.5 cms

Painted in Utrecht, about 1630

Moreelse painted at least three pairs of the two philosophers Democritus and Heracilitus (Knole, Kent, Lord Sackville; Utrecht, Centraal Museum and Chicago, Art Institute). In these instances two canvases are used. A further single Democritus (The Hague, Mauritshuis) would suggest a missing Heraclitus. This *Democritus and Heraclitus* is unusual in depicting both figures together, even though Democritus, the cheerful philosopher pointing to the globe (in this instance South America) and Heraclitus, the sad philosopher wringing his hands, are familiar from the single pictures. The two philosophers, Democritus of Abdera (about 460–457 BC to after 405 BC) and Heraclitus (working about 500 BC), are frequently paired in 17th century paintings.

Johan Moreelse was the son of Paulus Moreelse (Utrecht 1571–1638) who was the most successful painter in Utrecht in the early 17th century, especially for portraits. The dozen surviving works currently attributed to Johan Moreelse are strongly Caravaggesque and are all indebted to Ter Brugghen who was working in Utrecht in the 1620s until his death in 1629. The artist's work was first identified as a coherent group as recently as 1974.

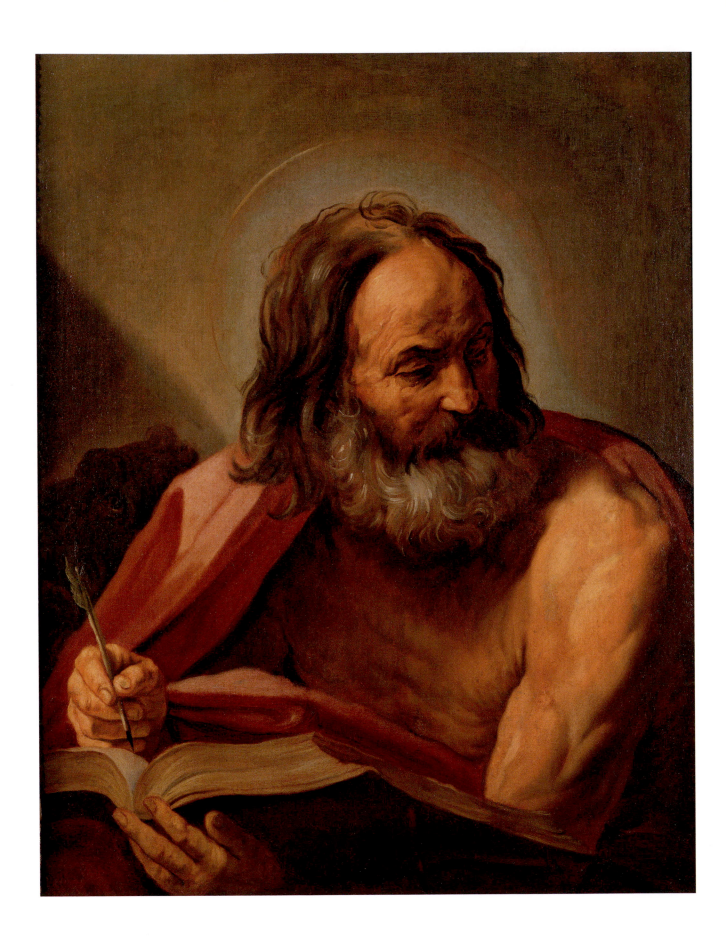

Guido Reni

(Bologna 1575–Bologna 1642)

The Evangelist Mark

Oil on canvas 91.2 x 71.2 cms

Painted in Bologna, early 1630s

The Evangelist Mark, writer of the second of the four gospels was the First Bishop of Alexandria and was martyred there. According to tradition his relics were translated from Alexandria to Venice in the 9th century where they remain. The saint is usually shown holding his gospel. With its characteristic freedom of brushwork and lightness of palette, the picture is a good example of the work from the artist's last decade in Bologna. Such pictures became especially esteemed by 18th century collectors, especially in France and England where many of them remained.

Reni's first master was Dennis Calvaert who also taught Francesco Albani and Domenichino. After his early success in Bologna, the artist left for Rome in 1607 where he was to remain intermittently for the first half of his career. Many of Reni's most ambitious frescos were painted in Rome, for the Vatican and for various palaces and churches. The latter part of the artist's career was spent working for the Gonzaga Court in Mantua (1617–21). He returned to Rome for the period 1627–32, working for Cardinal Francesco Barberini. The last decade of the artist's life was spent in Bologna, where he adopted a very different painting style.

Reni's stylistic development is linear. His earliest works are intense, tenebrist, and show a strong influence of Caravaggism. His mature work evolved into full-blooded Baroque, where his style is distinctive when compared with his contemporaries Guercino and Domenichino. The artist's later works are unexpected as they are innovative. He adopted a light palette and great freedom of brushwork, which seems to anticipate the 18th century.

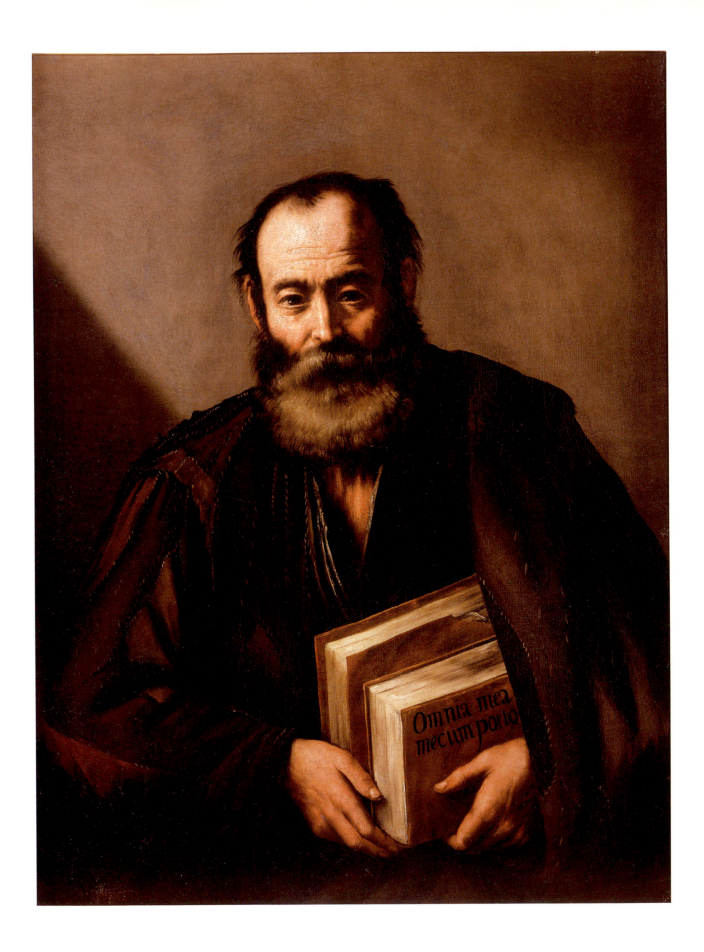

Jusepe de Ribera

(Játiva, Valencia 1591– Naples 1652)

The Greek philosopher Bias of Priene

Oil on canvas 102.9 x 76.2 cms

Painted in Naples, about 1630

The philosopher Bias, who was born in Priene in the 6th century BC, was often consulted by his fellow citizens in matters of litigation, and for this he became famous, even outside his immediate locality. The city of Priene was besieged by Cyrus the Great of Persia and all the inhabitants fled. Bias was indifferent to the disaster and made the famous statement that he was only taking his wisdom with him rather than material things. He was regarded as one of the Seven Sages of Ancient Greece, 'everything I have I carry with me'. The known account of Bias' life is derived from Plato's Protagoras.

The picture belongs to Ribera's early maturity in Naples, after his arrival from Rome, where he had already developed an intense tenebrism, much of it derived from the followers of Caravaggio such as Manfredi. Far too little is known about the original patrons of the numerous philosophers painted by Ribera, or the less numerous ones by Luca Giordano and Salvator Rosa. The intellectual background which inspired these works is also unknown, although Ribera could have acquired a taste for such subject matter during his early years in Rome.

The artist's first apprenticeship was to Francesco Ribalta (1564–1628) whose intense style had a profound influence on the young artist. It is likely that Ribera reached Rome at an early age, and he was certainly there by 1616 according to the early source of Mancini (Considerazione sulla pittura, Rome 1621). In these early years Ribera underwent a precocious development in common with so many young painters who came under the spell of Caravaggio, especially artists such as Manfredi and Tournier in his Roman period. The artist's stay in Rome was probably very brief as in 1616 he was also certainly in Naples where he remained for the rest of his career. In 1626, Ribera was elected to the Accademia di San Luca in Rome, and had many important clients both in Rome and Naples. Many of his main commissions were for the Certosa di San Martino and Duomo in Naples. Ribera's later development occasionally saw a lightening of his palette but he remained remarkably consistent throughout his career. It is now realised that Ribera's early work has long been attributed to the wrong artist – The Master of the Judgement of Solomon.

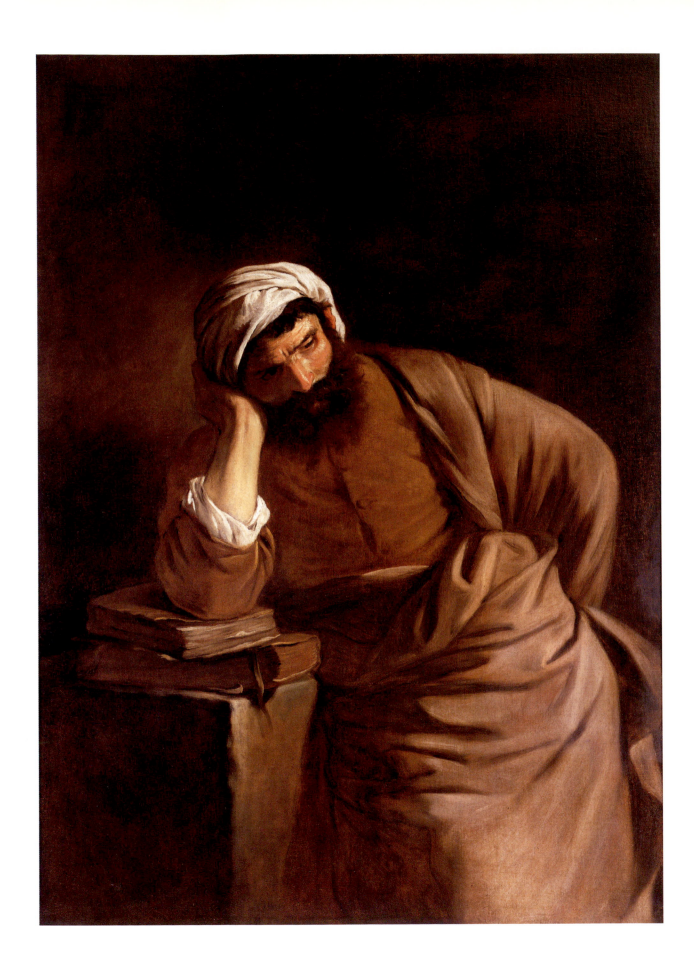

Salvator Rosa

(Arenella, Naples 1615–Rome 1673)

A Philosopher

Oil on canvas 136.5 x 99.5 cms

Painted in Florence, about 1640

This is one of the remarkably few pictures of this type currently attributed to Salvator Rosa. The invention of these solemn philosophers is entirely due to Ribera. Such works are generally thought to come from relatively early in the artist's career before he left Naples for Rome in 1647.

Rosa studied in Naples with his brother-in-law, Francesco Fracanzano, (1612–56) and also with Ribera (see page 115) and the battle-scene painter, Aniello Falcone (1607–56). All these Neapolitan painters had a strong influence, both on his style and subject matter. From 1640 Rosa spent nine years in Florence in the service of the Grand Duke of Tuscany, where he became involved in poetry and music. Rosa's range was remarkably wide and he was equally successful at each of the genres he tried. He was also one of the few painters of the time to delve into the mysteries of witchcraft, the occult and the macabre. His landscape style was also wide-ranging, stretching from the serene to the dark and brooding drama of storms and overhanging rocks. Apart from violent battle scenes, he also painted a few terrifying mythologies depicting dragons and snakes. His few portraits usually show the sitter in a state of melancholy. In the 18th and 19th centuries Rosa's work was especially favoured by English collectors and many of his key pictures remain in Britain especially in the Wallace Collection and Glasgow.

Peter Paul Rubens

(Siegen 1573–Antwerp 1640)

The Assumption of the Virgin

Oil on panel 55.1 x 67 cms

Painted in Italy, about 1608

The subject of *The Assumption of the Virgin* was based on the medieval Golden Legend and was not derived from any scriptural source. 'As the Apostles were sitting by the Virgin's tomb on the third day, Christ appeared to them with St Michael who brought him the Virgin's soul. And anon the soul came again to the body of Mary, and issued gloriously out of the tomb, and was thus received in the heavenly chamber and a great company of angels with her'. Rubens adopted this traditional account almost to the letter, although in this instance the whole composition is only visible in the complete modello in the Royal Collection. This spirited sketch can be dated on stylistic grounds to the surprisingly early date of about 1608, based on comparison with the very similar sketch in the Liechtenstein collection, Vienna.

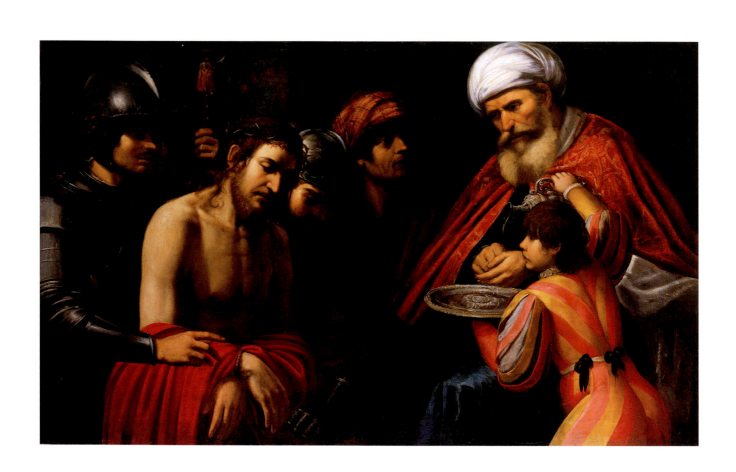

Leonello Spada

(Bologna 1576–Parma 1622)

Pilate washing his hands

Oil on canvas 113.5 x 186.5 cms
Painted in Bologna, about 1615–20

The event shows Pilate publicly washing his hands, following the Jews' request that he release Barrabas rather than Jesus. The painting is strongly Caravaggesque, and the use of the half-length figures is a device which the artist probably took from Manfredi. Unlike Manfredi, however, Spada uses a much more polished style, which shows the influence of other Emilian artists, even going back as far as Correggio (1489–1534).

Spada's early career in Bologna is generally considered to have taken place in the studio of the Carracci. Spada then went to Rome where it is thought that he became associated in some respect with Caravaggio. Most of Spada's later career was spent in Bologna, where a mixture of Emilian, Bolognese and caravaggesque influences were curiously mingled. In the period 1608–14 Spada executed frescos in the Palace of the Grand Masters of the Knights of St John at La Valetta, Malta. In his final years, Spada's main patron was Ranuccio Farnese in Parma.

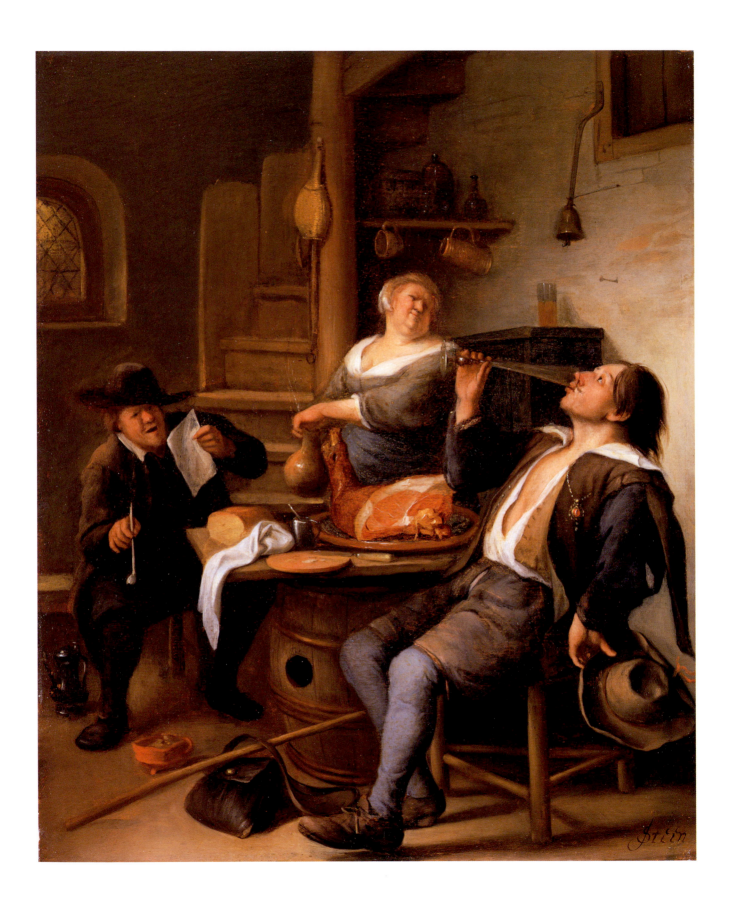

Jan Steen

(Leiden 1626–Leiden 1679)

Peasants in an interior

Oil on panel 38.1 x 31.1 cms

Painted in Leiden, about 1670

This picture belongs to the last phase of Jan Steen's varied career. In these later pictures his palette became much more monochrome, utilising greys and browns. As in so many of his pictures he was a passionate observer of low-life. His peasants are usually enjoying themselves: here there seems to be an excess of food and drink. The figure on the right is emptying a large flute, while on the table there sits an enormous ham. The large lady in the centre with her many chins brings a pitcher of something more to drink. The figure on the left holding a paper and a pipe strongly resembles the artist himself. While not specifically a self-portrait, Jan Steen often introduced figures into his pictures, with features very similar to those of his own.

Jan Steen's career is inextricably bound up with the fact that for part of his life at least he owned a brewery in partnership with his father. His apprenticeship is unknown but in 1649 at the age of 23, Jan Steen married Jan van Goyen's daughter. This marriage took place in The Hague, but by the early 1650s, Jan Steen was in Delft, and it was at this stage in his career that his paintings were at their most colourful. The artist continued to move around, as in 1658 he lived in Warmond, outside Leiden, and in 1660 he was in Haarlem. By 1670 he had moved back to Leiden where he spent the rest of his career. Jan Steen's subject matter is far more various than is generally realised. In Holland to this day a disorderly household is known as 'a Jan Steen household', referring to the artist's inimitable pictures of domestic disorder, which occasionally verge on the chaotic. Nevertheless, the artist could also produce elegant interiors, and religious subjects. As he grew older, his technique became less refined, and more monochrome, but he never lost his powers of observation of the human condition.

Dirck Jaspersz. van Baburen

(Wijk bij Duurstede about 1595 or earlier–Utrecht 1624)

Christ driving the money changers from the temple

Oil on canvas 161 x 199.5 cms

Painted in Utrecht in 1621

Christ driving the money changers from the temple was one of the most popular subjects throughout Europe in the 17th century and was subject to a wide variety of treatments. These ranged from the semi-humorous Jan Steen (Leiden, Stedelijk Museum 'De Lakenhal') to the intense approach of Caravaggesque artists such as Baburen here. The composition is especially complex as the artist has used the commonly-found Carravaggesque conceit of putting the main figure away from the centre of the composition. On the extreme left Christ wields a flail driving all before him, while those on the right, as yet unaffected, stare in surprise and amazement. The picture is of particular importance in reconstructing the artist's short career as its date places it firmly within the two years he spent in Utrecht.

Baburen was recorded as a pupil of Paulus Moreelse in Utrecht in 1611, and left for Rome shortly after. It was there that his Caravaggesque style was formed. His most important commission was for two large altarpieces for the Pietà chapel in S. Pietro in Montorio in Rome, probably in 1617, (*The Road to Calvary and the Entombment*), as well as a lunette of *Christ on the Mount of Olives*. In their complex composition and elaborate lighting, these pictures show how Baburen matured earlier than his two great Utrecht contemporaries, Gerrit van Honthorst and Hendrick ter Brugghen. On his return to Utrecht about 1620, Baburen's style did not change greatly, but he tended to produce more single figure genre pieces. The last dated pictures come from 1623. He died in February 1624.

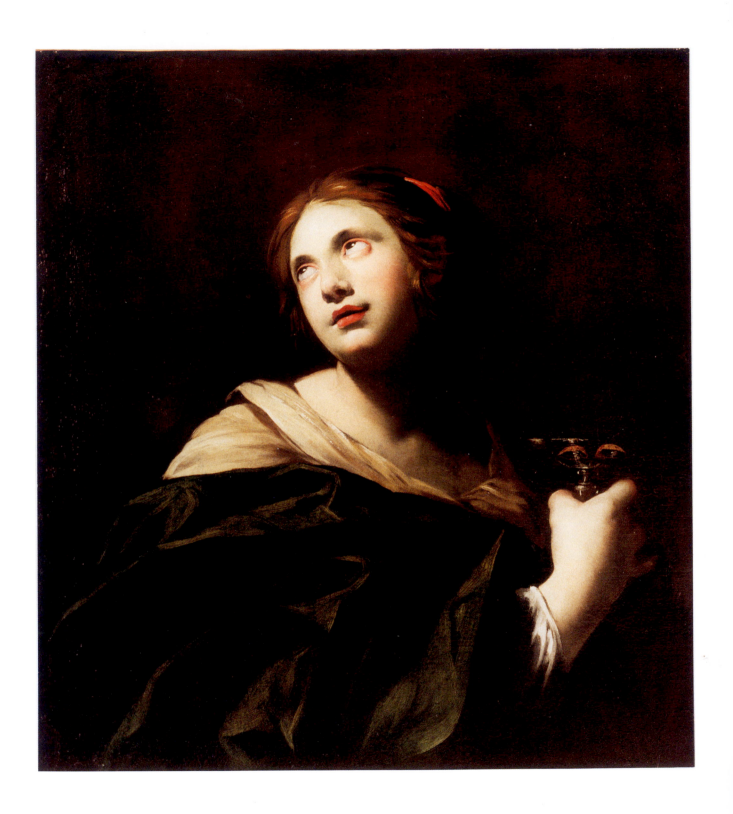

Simon Vouet

(Paris 1590–Paris 1649)

St. Lucy

Oil on canvas 77.8 x 73.8 cms

Painted in Genoa, early 1620s

This picture forms part of the small group of Vouet's work which are strongly Caravaggesque and without any of the decorative elements associated with his later work. The dramatic lighting and sharp focus on the face demonstrate how close is the debt to Caravaggio. Vouet painted relatively few single figures during his Italian period from around 1613–14 to 1627 as most of his work consisted of major altarpieces for Roman churches. On stylistic grounds the closest parallel is with the *David with the head of Goliath* in the Palazzo Bianco in Genoa which is generally dated to about 1621–22 at which time the artist was is in the city. In common with many early Christian saints, the deeds of St Lucy (martyred 304 AD) are largely mythical. Her story became popular in the 17th century, centring round the fact that, having lost her eyes during torture before her martyrdom under the persecution of the Emperor Diocletian, they were miraculously restored. Here she is shown with her eyes on the dish which she holds.

Vouet was the most successful of all French Baroque artists even though his career divides into two unequal and stylistically different periods. After early travel which included England, Constantinople and Venice, he arrived in Rome and spent the years 1614–27 there. Vouet established himself as the leading French painter concentrating on large altarpieces in a Caravaggesque style. He also received commissions for altarpieces in Naples and Genoa as well as for St Peter's in Rome. In 1627, Vouet was summoned to Paris by the young King Louis XIII and soon became the leading painter of the French Court. He established a large studio which provided elaborate decorations for Parisian town houses as well as a supply of ambitious altarpieces for Parisian churches. The artist also painted a large number of mythological pictures in a mature Baroque style which are mostly indebted to Italian models especially those of Guido Reni (see page 113). The artist's pupils in his studio included Eustache Le Sueur and Charles Le Brun and it was this development in the 1630s and 1640s under Vouet's domination that saw Paris as a leading artistic centre for the first time since the Middle Ages.

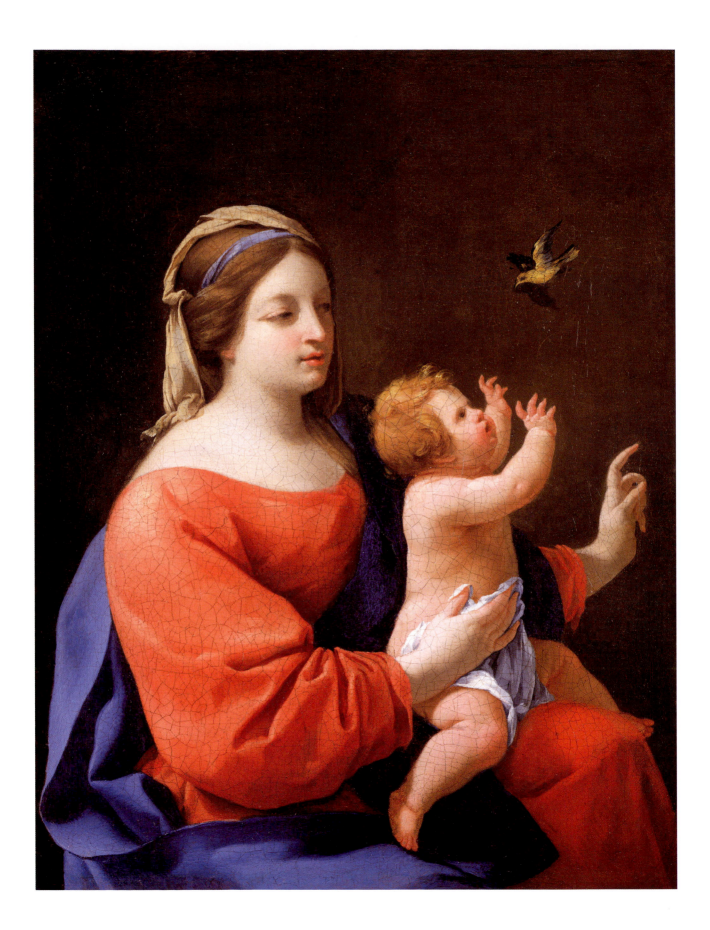

Simon Vouet

(Paris 1590–Paris 1649)

Virgin and Child

Oil on canvas 58.3 x 45.5 cms

Painted in Paris, about 1640

Vouet painted a few small scale pictures of the Virgin and Child in the late 1630s which can be dated from the surviving engravings. All these compositions are variations on the same theme, but each one with slight differences in the poses and the introduction of extra elements. Here the unusual feature is the finch which was common in the Renaissance but much rarer in the Baroque. The finch was much prized in the ancient world for its song and its ability to be tamed in captivity. The other small picture of this type (53 x 38 cms) is in a Paris private collection and was engraved by Jacques Daret in 1638. It is likely that the painting was intended as a devotional work for a private patron owing to its refined and precious quality which includes the use of the unmistakable blue, lapis lazuli.

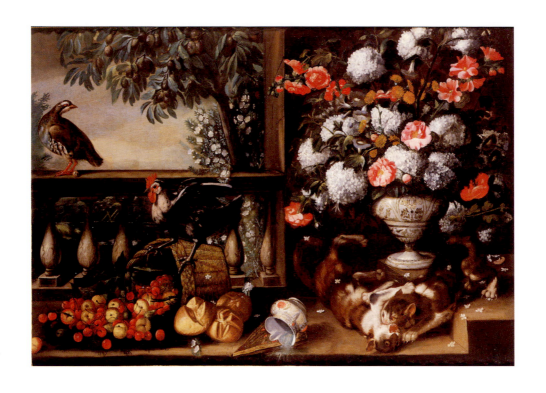

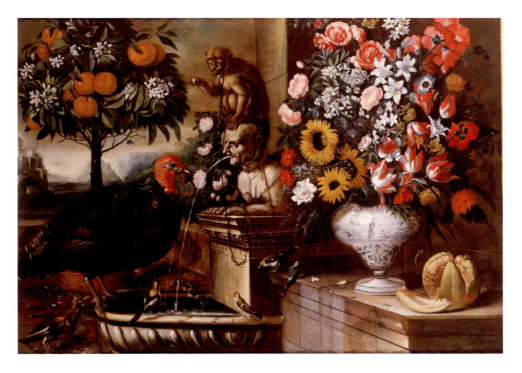

Tomás Yepes

(Working in Valencia 1616–Valencia 1674)

Cats fighting beneath the blue and white vase of flowers with a cockerel astride a fallen basket of cherries and apricots

Oil on canvas 115 x 156.5 cms
Painted in Valencia mid-17th century

These two large canvases represent the Baroque tradition in Spanish seventeenth century painting. This is a contrast to most of the other works of Spanish still life painting of the period especially Sanchez Cotan, Blas de Ledesma and Zurbaran whose work is characterised by a severity of both composition and colour scheme. Yepes on the other hand has all the exuberance of the Baroque coupled with a sense of humour. Such conceits as the cats fighting and producing mayhem in an ordered world are found in Flemish art of the same period where cats and dogs usually bring disorder in well-stocked larders. Not only does Yepes rely on the Netherlandish tradition for his humorous drama but the treatment of the individual objects is reminiscent of the Italian treatment of still life.

Tomás Yepes

(Working in Valencia 1616–Valencia 1674)

A monkey, a turkey and other birds around a marble fountain, with flowers and fruit

Oil on canvas 115 x 156.5 cms
Painted in Valencia mid-17th century

Yepes spent his entire career in Valencia and was admitted to the Colego de Pintores there in 1616. In spite of a long and successful career, very few pictures are currently attributed to the artist.

The artist's earliest known dated work is a *Still Life of a bowl of fruit and two vases of flowers* of 1642 in the Prado, Madrid. From the following year comes an unusual *Kitchen scene* where game birds are shown in a line hanging from hooks, which is also in the Prado.

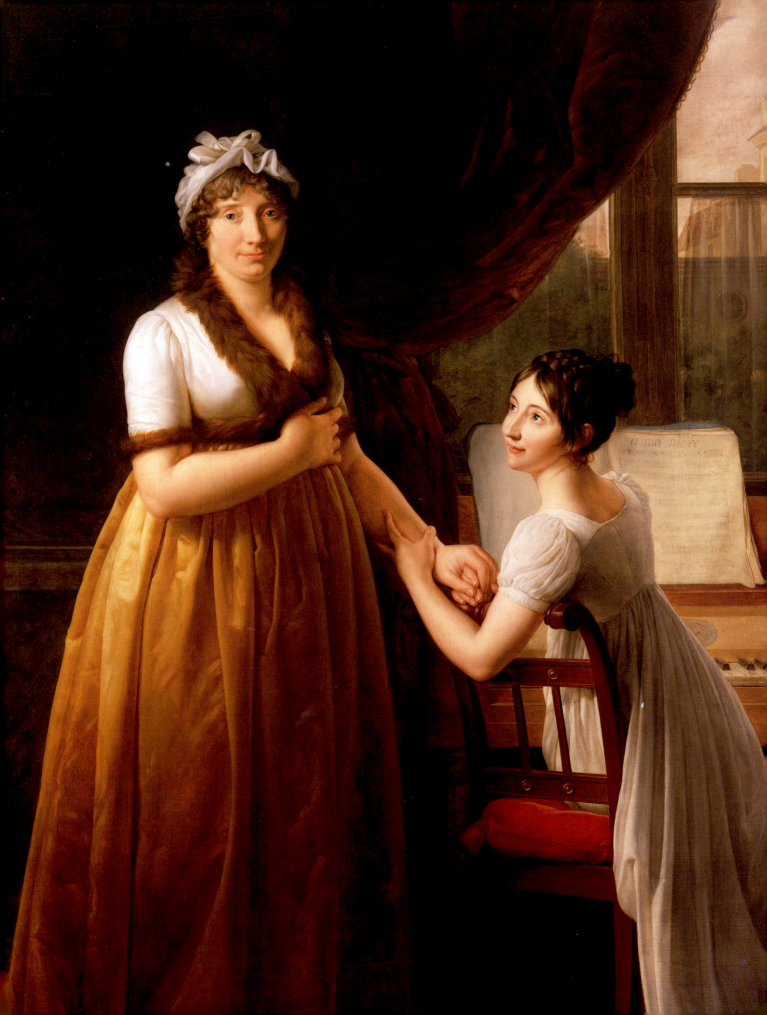

18ᵀᴴ CENTURY

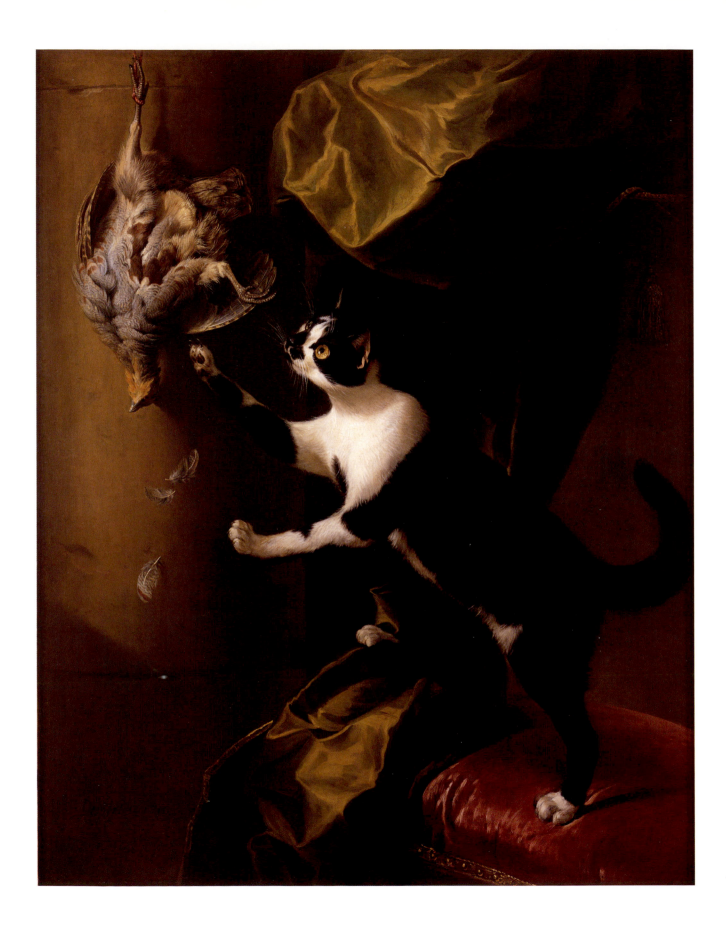

Alexandre-François Desportes

(Champaigneul, Haute Marne 1661–Paris 1743)

A cat with dead game

Oil on canvas 93 x 74.2 cms

Painted in Paris in 1711

The source for this painting is Flemish 17th century still life, especially the work of Jan Fyt (1611–61) and Frans Snyders (1579–1657). In the Flemish work, there is often an interaction between the animals and the dead game they so often guard. Deportes has 'modernised' the subject by simplifying the composition and adding a sense of humour to the scene. So far the cat has only succeeded in dislodging the feathers of the dead bird which is hanging just out of reach.

Desportes' early life seems to be based on a romantic story. The talented youth with an ability for drawing was apprenticed to the Flemish artist Nicasias Bernaerts (1620–72) who himself had been a pupil of the Flemish painter Frans Snyders. It was Snyders who was to be such a strong influence on Desportes' animal and game pieces. Desportes executed the prodigious number of some 2000 works in this genre which include animal paintings, still life, hunting scenes and specific depictions of plants and animals. However, one of his most celebrated works is a still life, the *Silver Tureen with Peaches* in the Nationalmuseum, Stockholm. The artist's reception piece for the Académie was a *Self-Portrait as a Hunter* of 1699 (Paris, Louvre). An early commission of importance was that from the Grand Dauphin for the Château at Meudon in 1709, the *Mort d'un chevreuil* (Compiègne, Château, deposited at Versailles). One of the artist's most important commissions was for a set of seven large pictures intended as tapestry cartoons in 1741. They are now separated between the Louvre and the museums of Guéret, Reims, Marseilles and the Préfecture de Lyon.

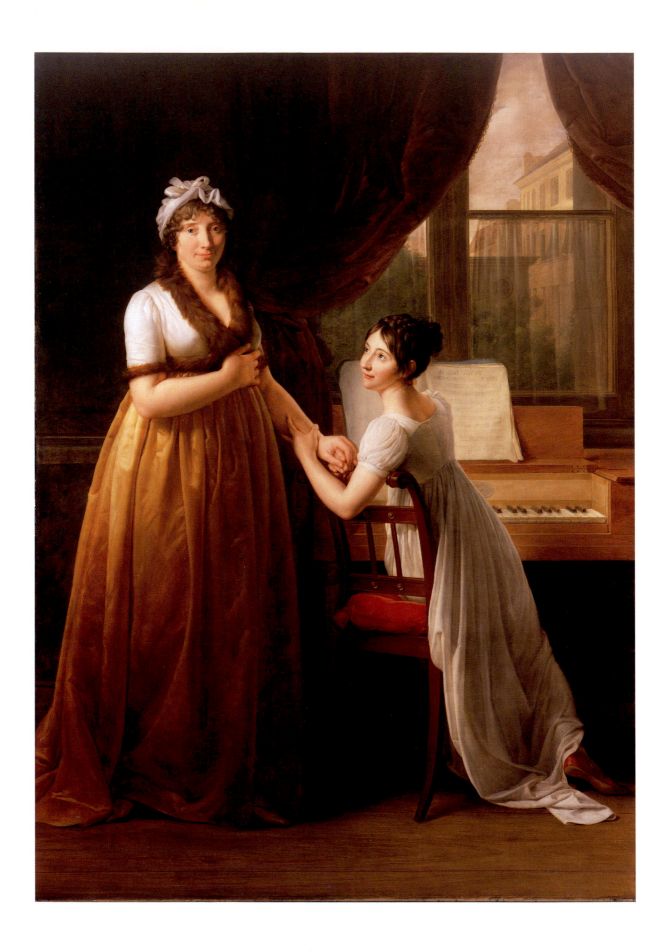

François Pascal Simon, Baron Gérard

(Rome 1770–Paris 1837)

Portrait of the de comtesse Morel-Vindé and one of her two daughters

Oil on canvas 205.7 x 147.3 cms
Painted in Paris, about 1799–1800

This painting is a version by Gérard of one which was commissioned by the sitter's husband, Charles Gilbert de Morel-Vindé (1759–1842) and passed by descent in the family until sold to the San Francisco Art Museums in 1979. The picture here is likely to have been commissioned at approximately the same time for another member of the family. The figures are treated with sensitivity within the rigid neo-classical composition. The colour scheme too is restrained, and even the surface textures are understated.

Gérard was one of the most prestigious academic painters of his time, in the wake of Jacques-Louis David (1748–1825), whose studio in Paris he entered in 1786. In 1789 Gérard entered for the *Prix de Rome* but was beaten by the more imaginative Girodet. Many of Gérard's early pictures were of classical or literary subjects such as the *Psyche et l'Amour*, exhibited at the Salon of 1798 (Paris, Louvre). However, the artist's best-known picture from this period is the *Portrait of the painter Isabey and his daughter* of 1796 (Paris, Louvre). Gérard was much favoured by Napoleon and received the commission to paint the Battle of Austerlitz, 1805 (Versailles, Château). He also painted portraits, not only of Napoleon but of all the other members of the Imperial family. Unlike David, who went into exile after the fall of Napoleon, Gérard painted many portraits for the restored Bourbon monarchy; first Louis XVIII and then his younger brother, Charles X. For the restored monarchy Gérard painted the immense *Sacré de Charles X à Reims 29 mai 1825* (514 x 972 cms) commissioned by the king himself (Versailles, Château). The artist's talent was to dilute the severe neo-classicism of David by prettifying it and therefore making it more accessible.

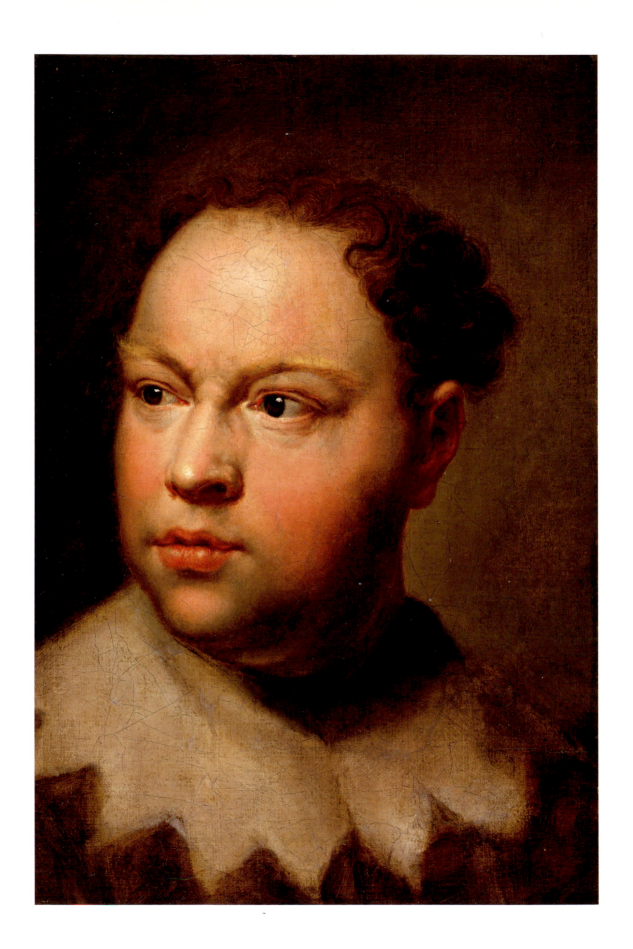

Anton Raphael Mengs

(Usti nad Labem (Aussig, Bohemia, now Czech Republic) 1728–Rome 1779)

Portrait of Father Gahagan, bust length

Oil on paper laid down on canvas 41.9 x 28.2 cms

Painted in Italy

Painted in Rome, about 1760

There appears to be no record for the painting of this picture. Nevertheless, it has all the character of having been done from life and its small scale meant that the addition of drapery was unnecessary.

Mengs was one of the most important artists of his generation, both from the extent of the commissions he received and the esteem in which he was held, as well as his influence with contemporary artists. After leaving Dresden as a young man, the artist visited Italy, returning to Dresden on occasion. In his later years in the city he painted both altarpieces and portraits for the court and then from 1756 onwards settled in Rome. There he painted numerous frescos, for which he became internationally famous. His inspiration was the work of Raphael, and he could be said to have created single-handedly a neo-classical style in Italy. The artist also spent time in Madrid working for the Spanish Court, mostly frescos and historical pictures. Shortly after his death, Sir Joshua Reynolds in his 14th discourse to the Royal Academy in London 1788 was curiously prophetic: 'I will venture to prophesy that two of the last distinguished painters of that country, I mean Pompeo Battoni and Raffaele Mengs, however great their names sound in our ears, will very soon fall into the rank of Imperiale, Sebastian Concha, Placido Constanza, Massuccio and the rest of their immediate predecessors'.

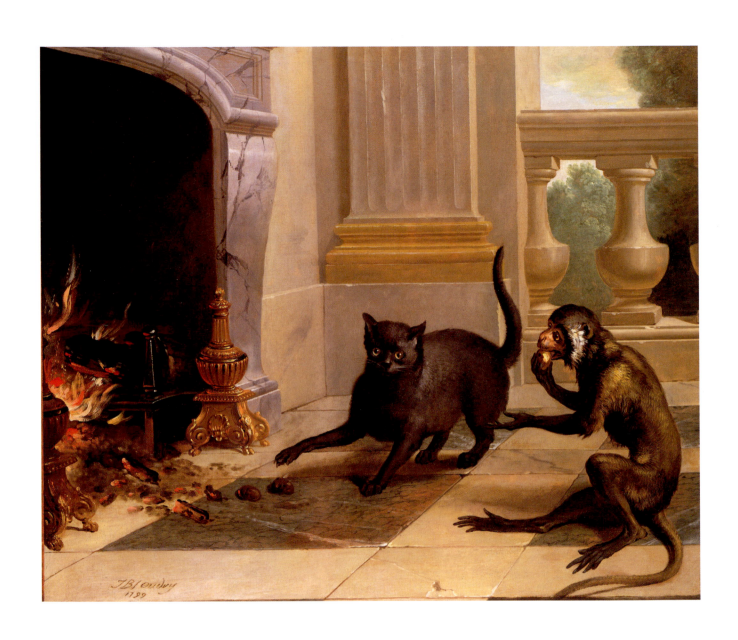

Jean-Baptiste Oudry

(Paris 1686–Beauvais 1755)

The cat and the monkey (from La Fontaine)

Oil on canvas 103 x 122 cms

Painted in Paris in 1739

The picture's subject is taken from one of La Fontaine's fables and there is a moral to be drawn on two levels. The story is simple enough. The monkey is content to scoff the chestnuts which the cat is laboriously taking from the fire at the risk of scorching his paws. At the third chestnut's retrieval from the fire, the servant comes in and the two rogues scatter leaving the cat without any chestnuts. La Fontaine's broader moral reads; 'And princes are equally dissatisfied when, flattered to be employed in any uncomfortable concern, they burn their fingers in a distant province for the profit of some king'.

Oudry is usually seen, along with François Desportes (see page 139), as one of the leading French still life and animal painters of the first half of the 18th century. In his early career Oudry had pretensions as a history painter. His first apprenticeship was to Nicolas de Largillière. His *Morceau de reception* at the Académie in 1719 was an *Allegory of Abundance and her Attributes* (Versailles, Château). In this picture, the young artist displayed an astonishing range of skills in still life, landscape, animal painting and figures. He also received an important commission for the apartment of Marie Lezczinska, Consort of Louis XV, at Versailles in 1749 for the set of the five senses (Versailles, Château). Oudry also painted a set of nine tapestry cartoons for the Gobelins manufactory, made by hand between 1735 and 1746, depicting the hunting scenes of King Louis XV. One of these is in the Louvre and the remainder at Fontainebleau. Later in his career Oudry's work concentrated on still life painting, and such pictures as the amusing story from La Fontaine here.

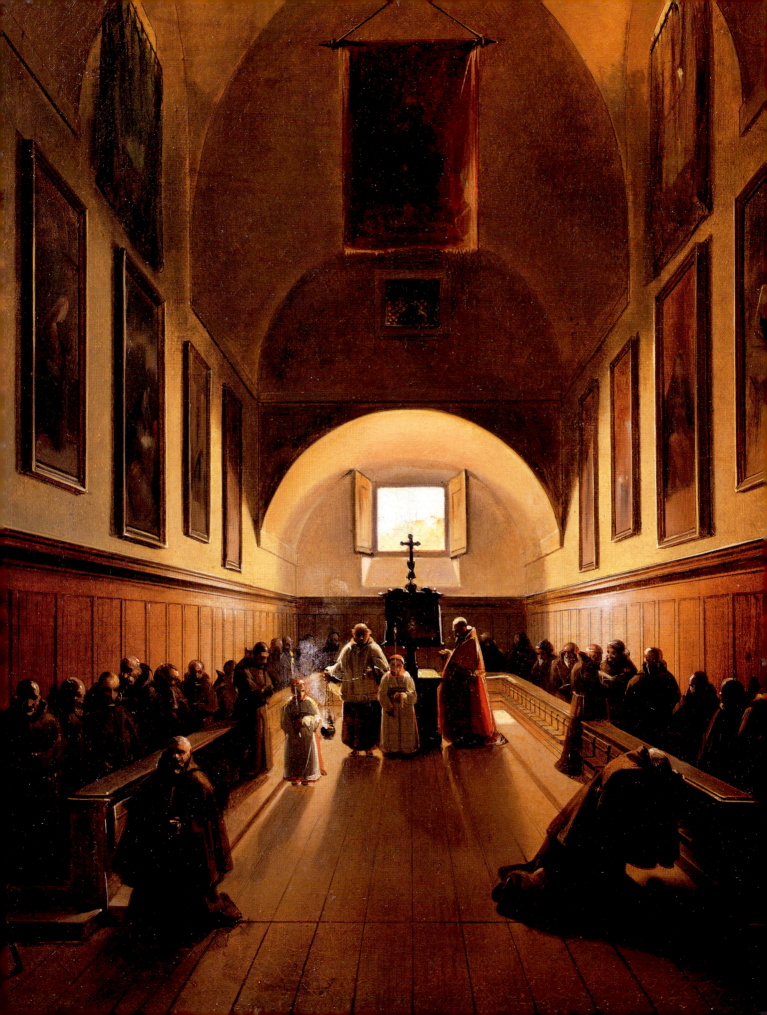

19ᵀᴴ CENTURY

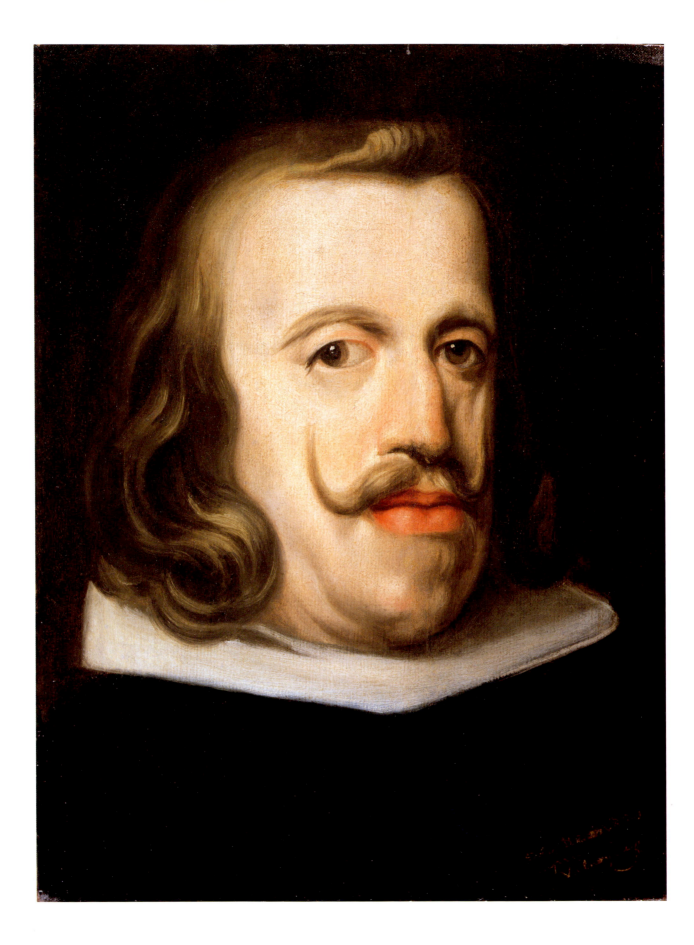

Eugène Delacroix

(Charenton-Saint-Maurice 1798–Paris 1863)

Portrait of King Philip IV of Spain, after Diego Velasquez

Oil on paper laid down on panel 39.5 x 29 cms

Painted in Spain 1832

The numerous copies Delacroix made after the old masters were generally subtle adaptations of the originals rather than precise copies. Delacroix often altered the mood of the original by addition of his own vibrant brushwork while preserving the essential accuracy of the composition. Examination of all the surviving versions of the painting by Velasquez, his pupils and followers, several of which Delacroix could have known, shows that Delacroix adapted the facial expression of the original. This picture is also important as an example of the revival of interest in Spanish painting which took place in France after 1815. This was partly due to the several hundred Spanish works collected by King Louis-Philippe (reigned 1830–48) which were exhibited in the Louvre but subsequently dispersed.

Of all the French painters of the romantic period, Delacroix was one of the most prolific and successful. The origins and development of his art are complex as in his maturity he had evolved an intensely personal style which reflected the old masters in its grandeur of scale and liberality of technique. Yet Delacroix was equally adept on an intimate format as his sketches and small works demonstrate. Delacroix's early artistic education was in the studio of the neo-classical painter, Pierre Narcisse Guerin (1774–1833). Delacroix first exhibited at the Paris Salon with this *Virgil and Dante in Hell*, a literary subject. It was in the 1820s that Delacroix painted a number of his large scale and enduring works such as the *Massacre at Chios* which was shown at the Paris Salon of 1824. This was followed by the *Death of Sardanaplus* of 1827 (both Paris, Louvre).

After the revolution of 1830, Delacroix's art entered a new phase when he was to enjoy the patronage of the new King, Louis Philippe. As a result of the revolution, Delacroix was to paint one of his most significant compositions, his *Liberty Leading the People* of 1831 in the Louvre. In the same year, Delacroix spent six months in Morocco and this was to influence him for the rest of his career in the frequent employment of oriental subjects. Most of Delacroix's copies and adaptations of the old masters come from the early part of his career.

Louis-Auguste-Gustave Doré

(Strasbourg 1832–Paris 1883)

Scottish landscape

Oil on canvas 112.1 x 195.6 cms

Painted in Paris in 1878

It appears that Doré was profoundly inspired by his visit to Scotland in April 1873. He even wrote to the English art critic, Amelia Edwards, 'Henceforth, when I paint landscapes, I believe that five out of every six will be reminiscences of the highlands – of Aberdeenshire, Braemar, Balmoral, Ballater etc. The artist was true to his word and there are several examples of these dramatic Scottish landscapes, many of them in American collections. These landscapes vary much in mood, ranging from the serene view, as in the example here, to the dramatic storm of 1875 in the Toledo Museum of Art, Ohio. The most gloomy of all is the *Scottish Eagle* of 1882 in a private collection in New York.

Gustave Doré was one of the most prolific artists of his time, especially since as an illustrator he executed some 500 woodcuts. He also illustrated numerous books, particularly in the 1860s, including Cervantes' *Don Quixote*, Chateaubriand's *Atala*, Milton's *Paradise Lost*, and most famously *The Bible*. Although born in Paris the artist was taken by his family to Bourg-en-Bresse in 1841, returning to Paris in 1847. In the period 1848–55, he executed 1379 drawings for the *Journal pour rire*. Doré entered the studio of Ary Scheffer (1795–1858) in 1855. He soon established himself both as a painter and as an illustrator. He began to execute impossibly ambitious works, for example, the *Battle of Inkerman* (480 x 500cms) commissioned for the Château of Versailles in 1856 when the artist was only 24. In the 1860s his reputation became international and he exhibited widely in London, Milan, Stockholm, St Petersburg, Warsaw, Prague, Arnhem, Amsterdam, The Hague, Dordrecht, Barcelona and Chicago. In his later career Doré concentrated more on painting. He also executed a number of illustrations and paintings which had a special appeal for the British market, and even though his paintings fell out of fashion, his illustrations always retained their popular appeal.

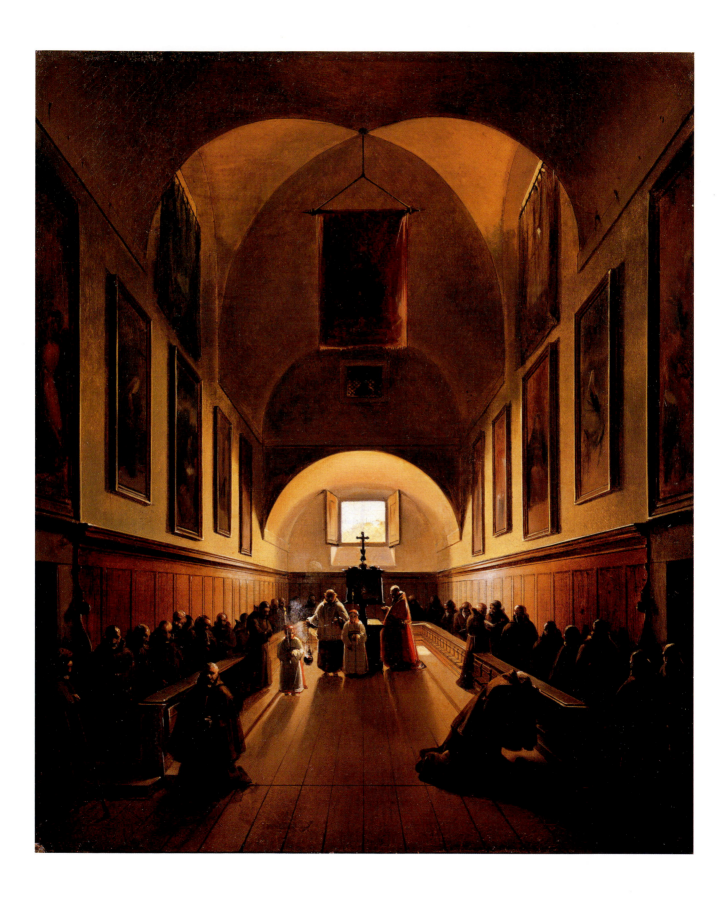

François Marius Granet

(Aix-en-Provence 1775–Malvalat, near

Aix-en-Provence 1849)

Interior of the Capuchin Monastery, Rome

Oil on canvas 46 cm x 37 cms

Painted in Rome, about 1815

The setting is the choir of the Capuchin Monastery on the Via Veneto, Rome, which was at the time a fashionable burial place for wealthy Roman citizens. Its painting collection, partly visible on the dimly-lit walls in the picture, contained the *St Francis* by Caravaggio. The earliest known version of the Granet composition, which bears a date of 1815, is in the Metropolitan Museum of Art, New York. A painting of this subject was bought by Caroline Murat, Queen of Naples and it may be the New York picture. It is possible, however, that the artist had worked on the composition for some time before. He certainly continued to paint replicas often with slight variations, the most prestigious being the one he presented personally to the Czar Alexander I of Russia in 1821, which had been painted in 1818. Not only did the artist repeat the composition with enthusiasm, moreover he introduced nuns into other versions. The picture was also much copied by other artists. The version here is by far the smallest and could well be a preparatory work for the series of compositions, all of which are very much larger.

Granet's early career was in his native Aix-en-Provence. He arrived in Paris in 1796 where he spent time in the Louvre copying the old masters. The artist's first pictures to be exhibited at the Salon in Paris set the mood and tone for his brilliantly successful career as a painter of tenebrist interior scenes. Granet's career falls into two distinct parts, his years in Italy from 1802 and his period as a museum administrator in Paris and Versailles from 1826 onwards. He became curator of the Louvre in 1824 and on the death of Landon in 1826, chief curator. At the end of his life he retired to his native Aix-en-Provence. He bequeathed to the Aix-en-Provence Museum (subsequently renamed the Musée Granet) his extensive collection of his own paintings and watercolours, some 300 in number. He also added a considerable collection of Old Masters to his bequest. Granet was also one of the most distinguished watercolourists of his time in France. His subsequent falling out of fashion has never been adequately explained, beyond the cyclical swing of taste, bearing in mind the importance and accessibility of the collections which contained his work. The artist also wrote an autobiography, the original manuscript of which is preserved in the Musée Arbaud at Aix-en-Provence. It was published posthumously in 1872, and gives a great deal of insight into the official art world of Granet's time.

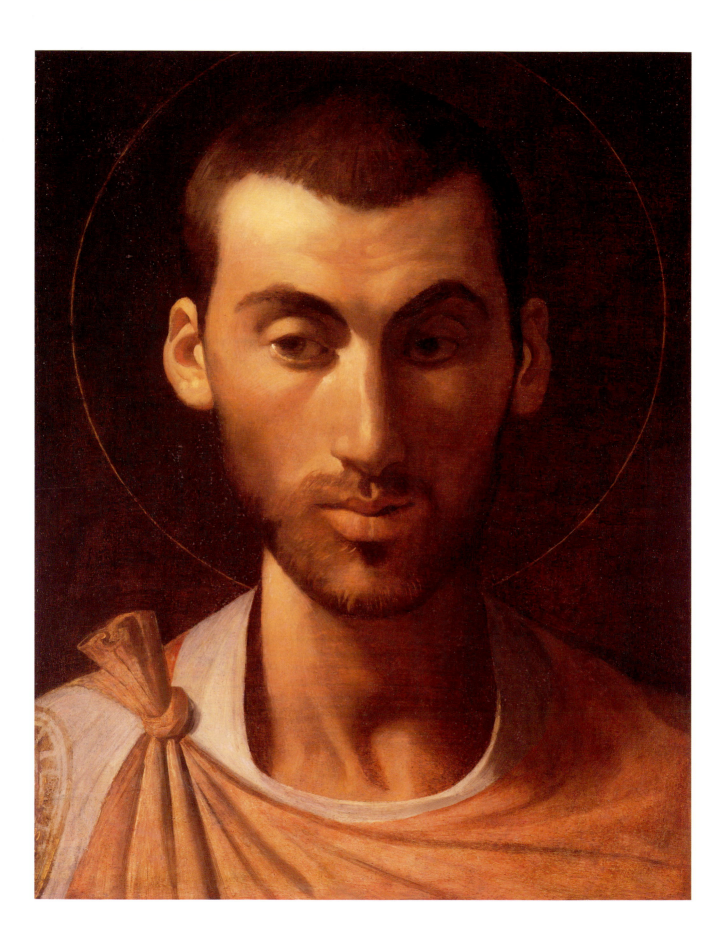

Jean-Auguste-Dominique Ingres

(Montauban 1780–Paris 1867)

Idealised portrait of Benoît-Joseph Labre, called Saint Labre

Oil on canvas 39 x 30.5 cms

Painted in Rome, about 1815

Ingres probably painted this picture as an idealised portrait of Benoît-Joseph Labre, who died in 1783. Labre had already become celebrated for his ascetic life, even though he was not formally canonised until 1881, and even then after much papal deliberation. Benoît-Joseph Labre (Amette near Boulogne-sur-Mer 1748–Rome 1783) seems more like a figure from the middle ages than a child of France's Age of Reason. Born poor, he spent the first half of his life making a continuous pilgrimage to many of the main sites in Italy and Spain, living off gifts rather than begging. By 1774, he was in Rome where he spent the rest of his life. Labre's asceticism, which was taken to excess, earned him a level of notoriety, and on his death at the age of 35 a hagiography grew up thanks to an immediate biography by his confessor – GL Marconi, *Ragguaglio della vita del servo di Dio, Benedetto Labre Francese*, 1783.

Ingres's father, Jean-Marie-Joseph Ingres (1754–1814) was a Montauban painter, sculptor and architect of local note, who was received into the Académie des Arts in Toulouse in 1790. Ingres himself entered the Académie in the following year as the pupil of JP Vigan, and GR Roques. The young artist soon received prizes for his copies after the Antique, and in 1797, he won first prize for drawing. Ingres left for Paris in the same year and entered the studio of Jacques-Louis David. In 1801, he won the Prix de Rome with his *Achilles and Patroclus* (Paris, Ecole des Beaux-Arts). Even so, the artist was not able to take up residence there for five years, as the French State had run out of available funds. As a result, the artist was given a pension of 60 livres per annum and a studio which was in the same neighbourhood as Girodet, Baron Gros and Granet. During this period, Ingres executed a small group of portraits, most famously *Monsieur Rivière, Madame Rivière and Madamoiselle Rivière* (all in the Louvre). In 1805 he exhibited in the Salon *Napoleon Enthroned* (Paris, Musée de l'armée).

In 1806, Ingres finally arrived in Rome where he was to remain until 1824. The artist's chief inspiration seems to have been the work of Raphael, and references to that artist were to appear throughout his work for the rest of his life. In 1807, Ingres painted the celebrated portrait of his friend the artist François-Marius Granet (see page 153), Aix en Provence, Musée Granet. This was followed by one of the artist's purest neo-classical compositions, the *Baigneuse de Valpinçon*, Paris, Louvre. In these years, Ingres' style became more extreme, taking the neo-classical elements further away from the original theoretical purity of David. This culminated in the *Jupiter and Thetis* of 1811, Aix-en-Provence, Musée Granet. In his long later years, Ingres' style evolved but little and he became a grand old establishment figure, the antithesis of Delacroix (see page 149).

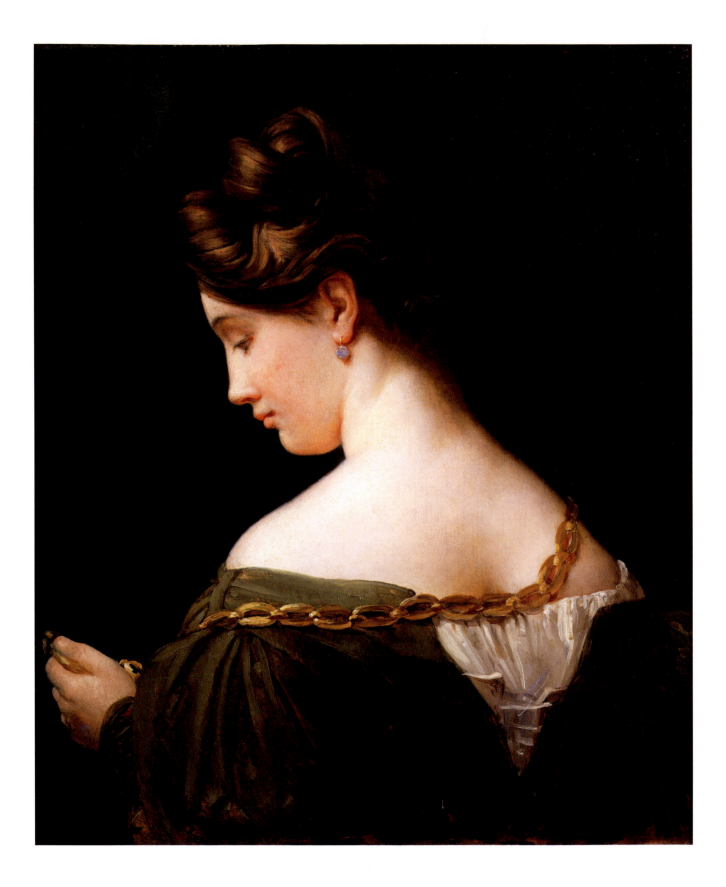

Auguste Jean-Baptiste Vinchon

(Paris 1789–Bad Ems 1855)

Portrait of Madame Ary Scheffer (died 1856)

Oil on canvas 65.5 x 54 cms

Painted in Paris, probably 1830s

The pose and general treatment of the subject is self-consciously derived from the old masters. The treatment of the sitter is hardly a strict portrait as she is seen in profile and in the act of contemplation. The heavy gold chain she wears and the dress worn off-shoulder is also a tribute to Renaissance and Baroque masters. The possible date of the painting has to be deduced from the apparent age of the sitter. Her husband, the artist Ary Scheffer (1795–1858), was well known in Paris from the 1830s onwards.

Vinchon was a pupil of the Italian neo-classical painter Giuseppe Serangeli. Vinchon won the Prix de Rome in 1814, and on his return to Paris he became closely involved in the religious revival under the aegis of the restored Bourbon monarchy. The artist's most expansive and successful pictures were a series of episodes from the *Life of St Maurice* for S. Sulpice in Paris, and he also painted a Dead Christ for the Eglise de S. Paul, in Paris. He also painted a large number of grisailles from Greek history which are in the Louvre, Paris. However, in common with many artists of his time, Vinchon made a considerable reputation as a portrait painter. Vinchon's later work was quite different as he embraced a more romantic but still old-fashioned style. The best example of a picture of this type was exhibited at the Salon of 1847, *Episode de l'histoire de Venise, Torture d'une jeune patricienne dont le fiancé est soupçonné de comploter contre Venise*, Paris, Louvre. The artist also executed a few historical scenes such as the *L'enrôlement des volontiers, 22 juillet 1792* of 1850 (Lunéville Château).

Index

A full two volume publication of the entire Schorr
Collection is in preparation and due to be published in
mid 2011

HUGH BAIRD COLLEGE
LIBRARY AND LEARNING CENTRES